12

Ulay
What Is This Thing Called Polaroid?

Frits Gierstberg
Katrin Pietsch

Valiz Foundation, Amsterdam
Nederlands Fotomuseum, Rotterdam

Contents

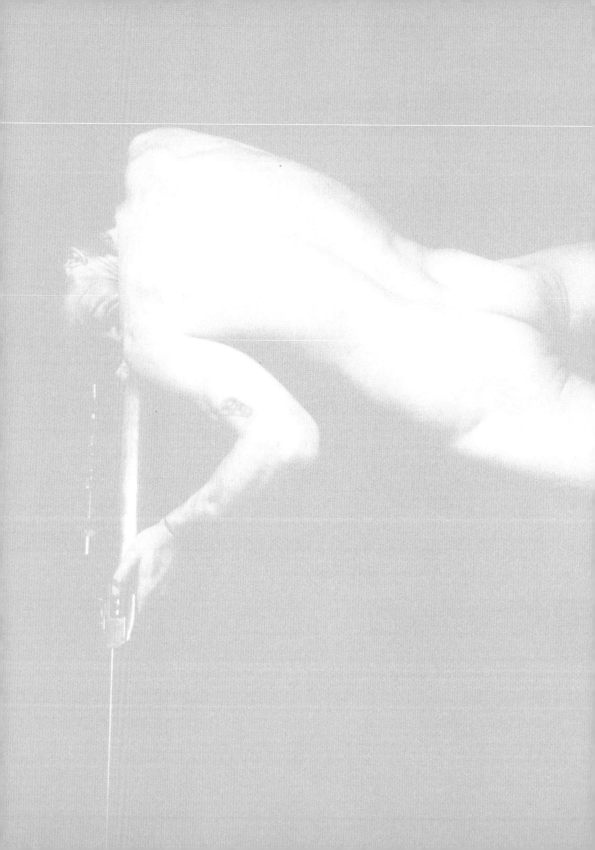

Ulay's Second Skin

Frits Gierstberg

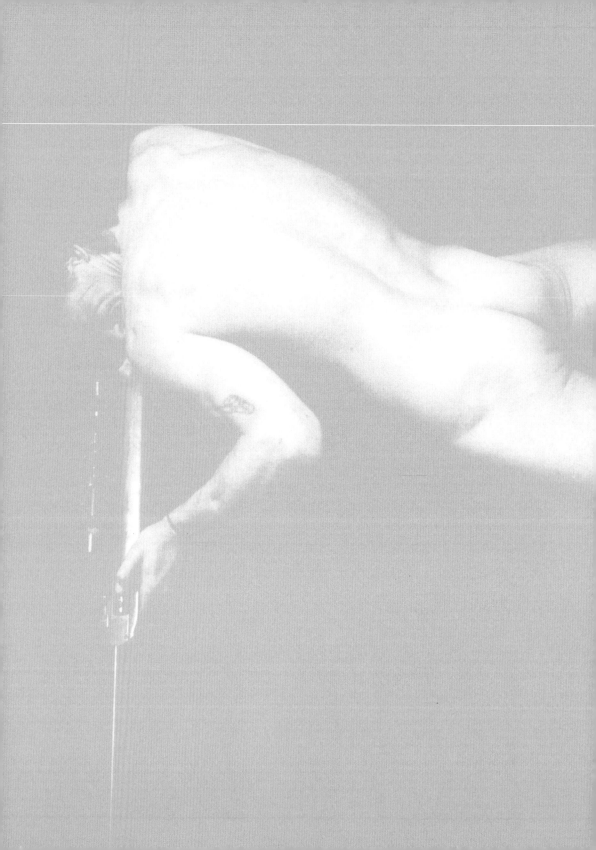

1
Ulay to author, Ljubljana, May 2015.

2
Although Ulay is not mentioned in several Polaroid surveys, such as Steve Crist and Barbara Hitchcock (eds.), *The Polaroid Book: Selections from the Polaroid Collections of Photography* (Cologne, 2005); Deborah Martin Kao, Barbara Hitchcock and Deborah Klochko, *Innovation/Imagination: 50 Years of Polaroid Photography* (New York, 1999); *American Perspectives: Photographs from the Polaroid Collection*, exh. cat. Metropolitan Museum of Photography (Tokyo, 2000).

Ulay once said: 'I hurt my skin more than I ever hurt Polaroid film.'[1] That seemingly strange pronouncement aptly expresses Ulay's artistic, physical and emotional relation with Polaroid as a medium. This artist has certainly done violence to his body, and he has become one with his medium to such an extent that you could speak of an intimate physical relation between the two. For him the unique character of each Polaroid photograph was not just a technical limitation, but was the perfect match for the ethical basis of his work. Polaroid became his second skin. Human skin and photographic film – they are both photosensitive protective layers of the active chemical substance that lies beneath.

That is one of the reasons why it is impossible to talk about Ulay without talking about Polaroid. Vice versa, it is not possible to talk about Polaroid without referring to the work of Ulay either.[2] Seldom in the history of art have art, technology and artist been so intricately entwined as in his case. Of course, all good artists choose their technique(s) on the basis of content and artistic vision, so that art and medium, content and form are always one, but for Ulay that unity has assumed radical forms. His sublime mastery of the technique and the kind of experiments that he conducted with it led him to even start working physically *inside* the camera once the development of an extremely large-format Polaroid camera made that possible.

Ulay, *Soliloquy*, 1974
From the series *Renais sense*
Auto-Polaroid type 107

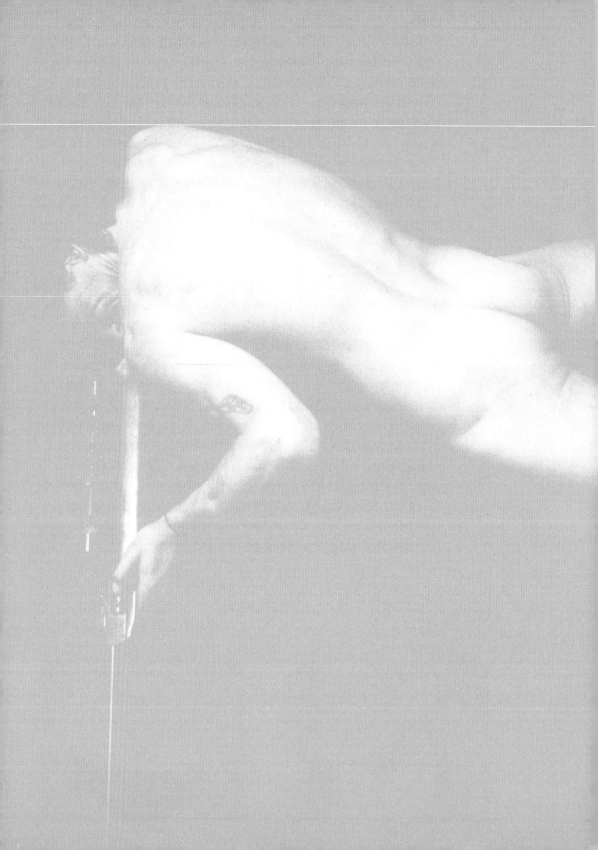

3
See the article by Katrin Pietsch in this book.

4
Polaroid actually covers two techniques. The first (taking the shot) is photography; the second (when the image is produced by the chemical effect of layer 1 on layer 2) resembles a printing technique.

5
Polaroid stopped producing film material in 2008, thereby threatening to make 200 million Polaroid cameras all over the world redundant. In the following year former employees of the Polaroid factory in Enschede organised a relaunch under the name The Impossible Project, using an old Agfa technology to emulate Polaroid instant film. By now 'Polaroid' prints can be made with digital cameras. See www.the-impossible-project.com.

But What Is Polaroid?

Polaroid is an instant photograph technology developed from the late 1930s by the US physicist, inventor and entrepreneur Edwin Land (1909–1991).[3] The Polaroid principle was based on a chemico-mechanical process, making use of an emulsion that was sandwiched between two layers of paper like an envelope. At first the user had to peel one layer from the other by hand, but later that process was carried out inside the camera. The first fully automatic instant Polaroid camera was the SX-70, which was launched in 1972. It became an extremely popular model and was a great commercial success. You took your picture, and almost immediately the exposed but apparently blank sheet of photographic paper was ejected from the camera. The picture gradually materialised within about 60 seconds. Ready! Every print is a unicum.

The SX-70 produced roughly 8 × 8 cm images on paper measuring 8.8 × 10.7 cm. The aesthetic white border, which was a little broader at the bottom, was a typical feature that made it possible to recognise a Polaroid photograph from a distance. The reverse side of the paper was a matt black. After all, the Polaroid photo-graph is not an ordinary print on paper, but an image that is the result of a chemical process that takes place between two layers of paper.[4] The two layers and the chemicals between them are permanent, which is what gives the photograph a certain thickness. Through the absence of grain, the Polaroid photograph is incredibly detailed to a level beyond what the human eye can perceive. The rise of digital photography put Polaroid virtually out of business, although even the most advanced digital cameras still come nowhere near the resolution of a Polaroid print.[5]

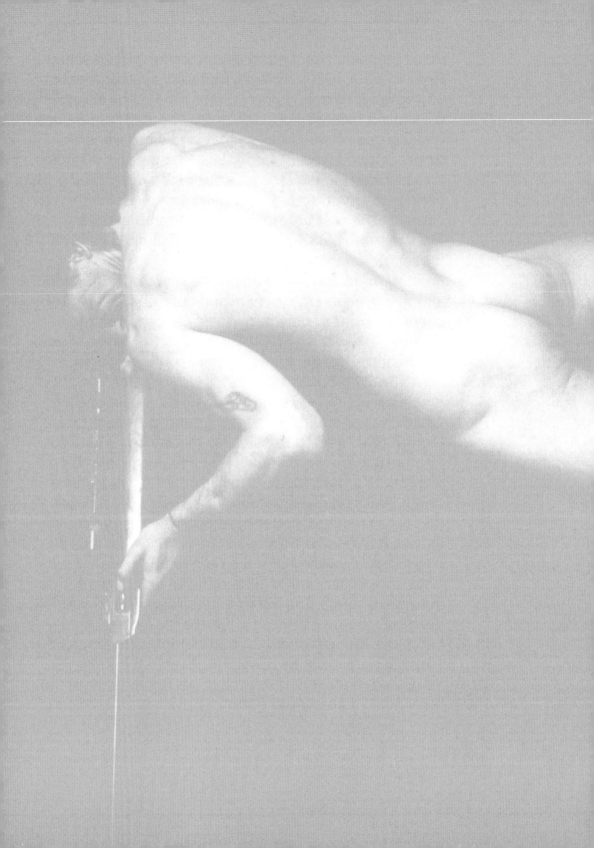

6

See Barbara Hitchcock, 'When Land Met Adams', in: Crist and Hitchcock 2005 (note 2), pp. 12-17.

7

Westlicht. Center for Photography, Vienna (www.westlicht.com); part of the Polaroid Collection was auctioned by Sotheby's in New York in 2010. See Rosan Hollak, 'Foto's failliet Polaroid halen veiling-record', *NRC Handelsblad* 22 June 2010, pp. 1 and 9.

8

The Polaroid 180 camera, in which the two layers of the film had to be peeled off by hand. The format was 8.5×10.8 cm. In some occasions he used a Polaroid 4×5 inch film holder in a technical camera, producing sizes of 10.7×13 cm. Ulay worked with type 107, 3000 ASA black-and-white film, or type 108, 100 ASA colour film. He never used flash.

Polaroid was a big success because of its practicality, but it was also very popular among artists. The company adopted a generous policy of giving artists and photographers Polaroid material to experiment with free of charge in exchange for work made with a Polaroid.[6] In this way Polaroid amassed a collection of more than 4,000 works by some 800 artists, from Ansel Adams to Andy Warhol, between 1972 and 1990. The International Polaroid Collection was given a permanent seat in Vienna in 2011.[7]

Ulay worked from the start with a non-automatic Polaroid 180 camera that produced other formats.[8] He later experimented with large formats, such as the camera that could make 20 × 24 inch (50 × 60 cm) prints, and even with a 40 × 80 inch (110 × 220 cm) Polaroid camera.

Ulay, *Auto-Portrait*, 1970
Polaroid type 108

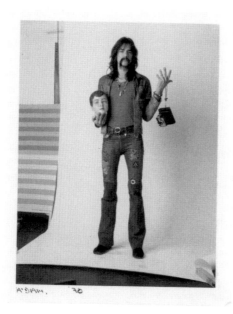

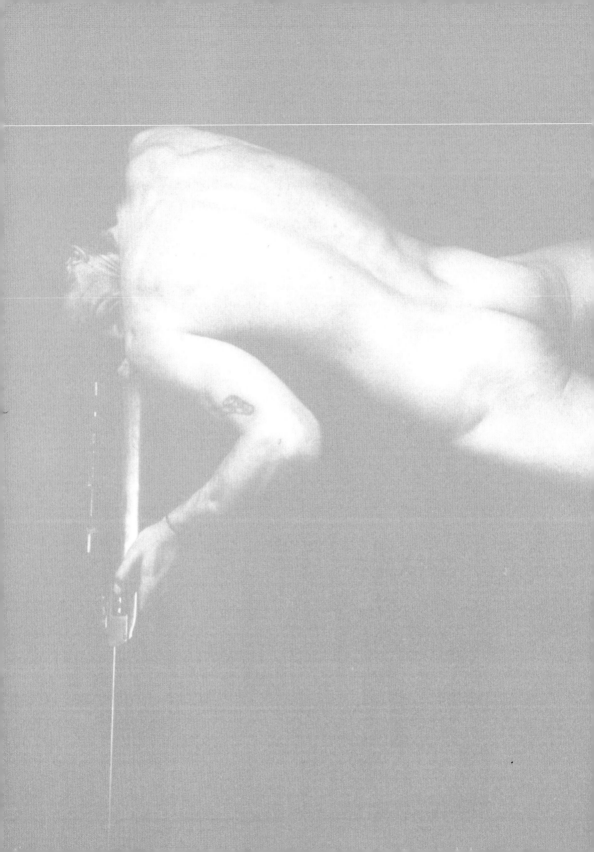

9
See e.g. Wim Beeren, *Actie, werkelijkheid en fictie in de kunst van de jaren '60 in Nederland*, exh. cat. Museum Boymans-van Beuningen (Rotterdam, 1979); *Amsterdam 60/80: Twenty Years of Fine Arts*, exh. cat. Museum Fodor (Amsterdam, 1982), pp. 108-109; Marga van Mechelen, *De Appel. Performances, installaties, video, projecten 1975-1983* (Amsterdam, 2006).

10
For more on Ulay's life and work see: Maria Rus Bojan and Alessandro Cassin, *Whispers: Ulay on Ulay* (Amsterdam, 2014).

Introduction

Ulay's introduction to Polaroid technology was more or less fortuitous. It was in 1969, after he had radically changed his life by leaving his home in Germany and moving to Amsterdam with little more than an Adler typewriter in the boot of his car. Amsterdam, at the time a lively centre of artistic innovation and social experiment, attracted him for the anti-bourgeois mentality of the Provos, whom he called 'constructive anarchists'.[9] Although the movement was in decline by then, Ulay found in it the personal freedom that he was looking for. He left behind him an unhappy childhood: born in a bunker during the Second World War, he had lost his father early and split up with his first wife. After training as a technical photographer, he ran a commercial photo lab until he closed it down and left. Ulay did not have any artistic ambitions at that time.[10]

Ulay, 1970

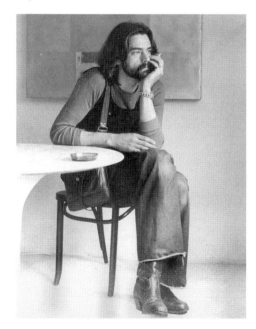

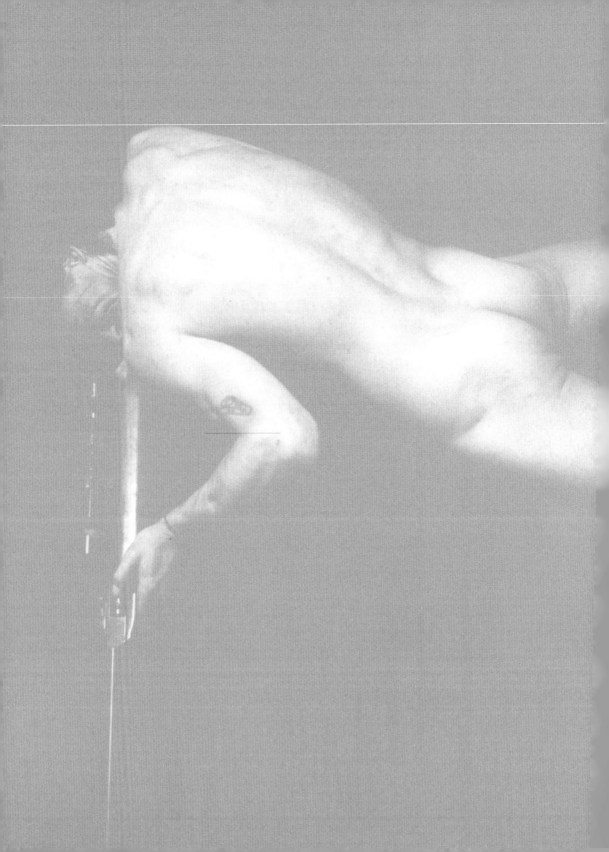

11
Scott Miller (ed.), *Uwe's Polaroid Pictures of 5 Cities: Photographed and Narrated by Uwe Laysiepen* [Amsterdam, 1971].

Ulay recalls being introduced to the phenomenon of the Polaroid camera in Amsterdam by the artist Aat Velthoen. He was immediately fascinated by the technology. The ingenious system, the attractive design, the particular aesthetic of the image with its perfect surface, and especially its instant quality, were irresistible for him. Once he had discovered that the European head office of Polaroid was located in Amsterdam, run by Manfred Heiting (who later became a photo collector), an almost lifelong connection was rapidly born. Ulay became an international consultant to Polaroid in 1971 and was given unlimited access to Polaroid material and equipment.

Ulay's first contacts with Polaroid Amsterdam led to a contract to make a Polaroid book of cities, which took him to London, Paris, New York and Rome as well as photographing Amsterdam. *Uwe's Polaroid Pictures of 5 Cities*, his first book, was published in 1971 in an edition of 80,000. He also wrote the accompanying texts.[11]

Ulay's Identity Card for his job as Polaroid's photo consultant, 1973

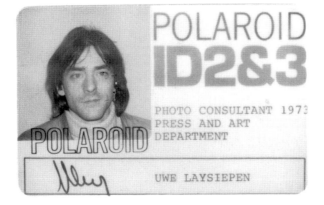

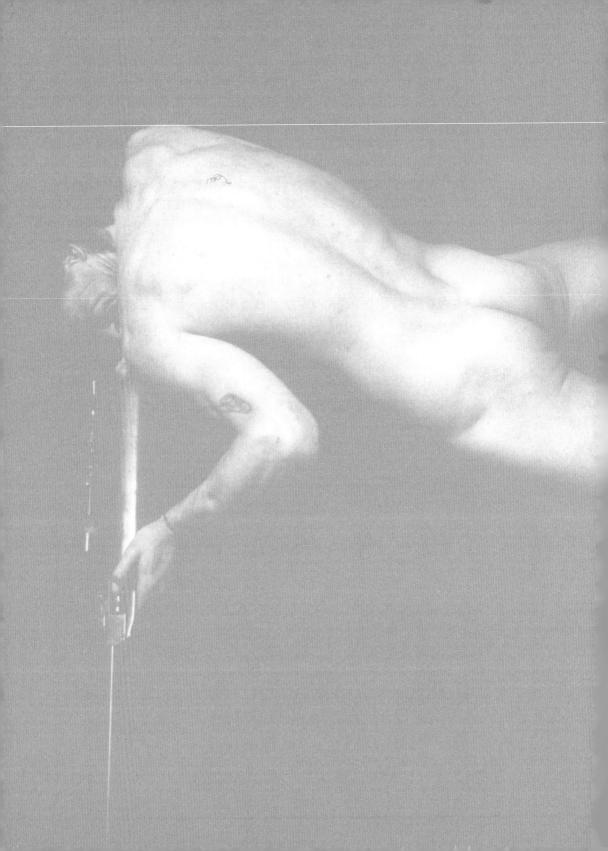

12
Rus Bojan and Cassin 2014
(note 10), p. 192.

Identity

It is hardly surprising that a person who resolutely shuts the door on his past and starts again somewhere else will question his identity. The switch to a different language also plays a part; Ulay felt he had been born again.[12] Those questions were absolutely fundamental: they touched on the most tangible proof of his existence, namely his body, its autonomy, and the meaning that it has or takes on in relation to the social surroundings and culture in which it emerges. The first social connotation that the body assumes, at the first moment at which it loses its autonomy or self-identity, is that of gender.

Ulay embarked on a highly personal investigation of his own identity in relation to such aspects as the prevailing social conventions and the field of tension between men and women. Given his background in photography, his choice of the medium to document was perhaps logical or natural; the instant photography of Polaroid opened the door to a completely different universe in which the relation between artist and technology is not only more intimate, but also full of meaning. For Ulay Polaroid enabled the direct connection with life itself. He performed countless actions in which he dressed up and sometimes applied make-up, indefatigably recording them all with the Polaroid camera. His name for them, Auto-Polaroids, says it all. This performative photography from the period 1970–1975, presented under the title *Renais sense*, usually resulted in small series.

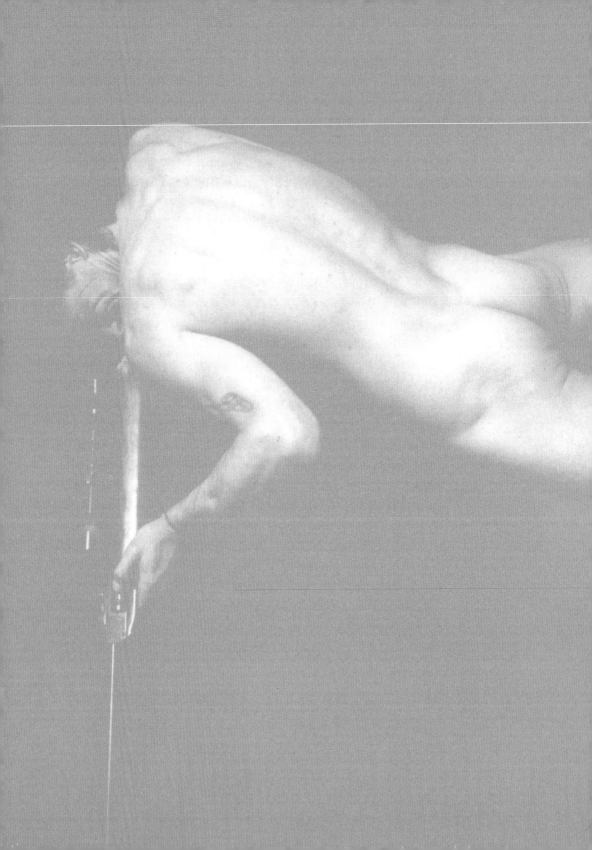

13
It was not until 1974 that friends (the collectors Martin and Mia Visser) managed to convince Ulay to exhibit his Polaroids in the Amsterdam gallery Seriaal - forerunner of De Appel. He had his reservations at the time and was afterwards very disappointed by the negative reactions of the public, who apparently did not know what to make of the photographs displayed geometrically on an iron wall in metal Polaroid film containers. He decided not to do any more exhibitions for the time being.

14
See Van Mechelen 2006 (note 9), pp. 62-63 and p. 98.

Ulay did not immediately become an artist. In retrospect we can call the Auto-Polaroids works of art, but Ulay certainly did not regard himself as an artist during that initial period, and as far as he was concerned he was not making anything to be seen by other eyes.[13] In Amsterdam he hung out mainly with transvestites and transsexuals, people who were also wrestling with the identity they had been born with or at least calling it seriously into question. They wanted to go against the socially accepted conventions and be different. So Ulay's concern with identity was not the result of reflection on the life of an artist, but of his life as a human being. It was fundamental or existential and thus had a directly ethical dimension. That was to remain, because the distinction between a person and an artist would become meaningless to him. 'I'm still an artist when I'm asleep', he used to say.

All the same, in the early period he was not far from the art world, as shown by his friendship with another German artist, Jürgen Klauke (1943), which later led to a collaboration. Ulay was a regular visitor to Klauke in Cologne at the time. Klauke shared a similar questioning of identity and gender, cultivated an androgynous look, and took photographs of himself dressed up and with make-up (though never with a Polaroid). Characteristic works in this connection are *My First Journal* (1969–1970), the book *Ich und Ich* (1972), with autobiographical drawings by Klauke and Polaroids by Ulay, *Selfperformance* (1972–73) and the *Transformer series* (1970–75). Ulay and Klauke collaborated on *Duel I* (1970–71) and *Duel II* (1972). In 1975 they staged a joint performance in De Appel called *Keine Möglichkeit 2 Platzwunden*.[14]

Ulay, *Keine Möglichkeit 2 Platzwunden (with Jürgen Klauke)*, 1975
Performance documentation from De Appel, Amsterdam, NL

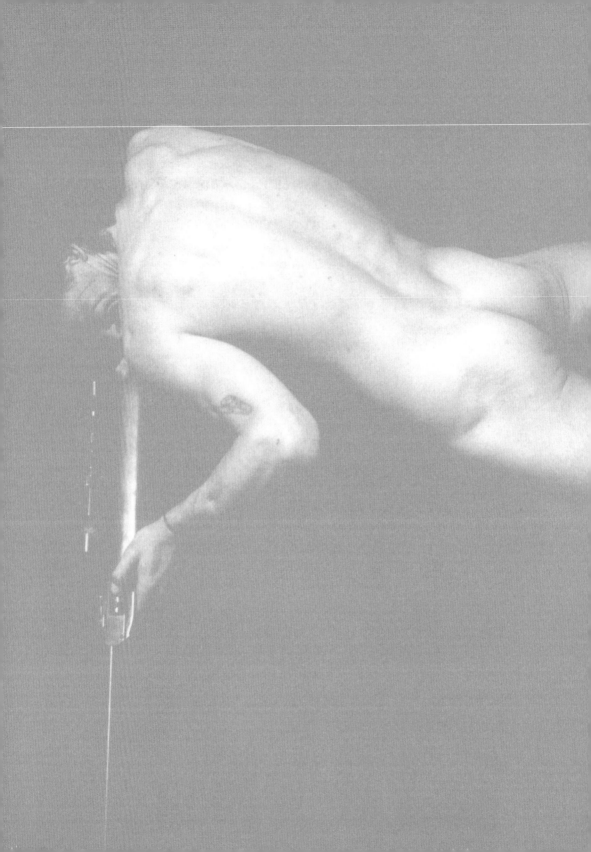

Given the relative lack of familiarity with the medium, Ulay's decision to work with Polaroid was certainly not an obvious one, although many artists showed an interest in photography after the medium had been introduced in Conceptual Art in the 1960s. His focus on identity and the reflective character of his work on both his own body and photography as a medium was a part of that broader interest. The self-reflective revolution in art by which art became its own subject was largely in line with the structuralist philosophical movement, which fundamentally undermined human identity by seeing it as part, or even product of larger systems that are not themselves fixed. One of the latter is language, which confers meaning on reality but has no permanent foundation from which to do so. See e.g. Douglas Fogle, *The Last Picture Show: Artists Using Photography, 1960-1982*, Walker Art Center (Minneapolis, 2003).

'Auto' is a word that he loves. It fascinates him with the reference to autonomy and self, as well as autodidact. It also suggests automatism, an action from which thought is virtually excluded: the detachment of body from mind, and automated (in a certain sense the Polaroid is semi-automatic). We can immediately see Ulay's interest in language and the role it plays in his searching for and playing with identity. He used the Adler typewriter he had brought from Germany to write aphorisms, even sometimes typing them directly on the Polaroids so that the interaction between language and image had a very direct effect. The broken form and meaning of the title *Renais sense* are also indicative of the role of language in Ulay's work – it refers to rebirth, feeling, direction and understanding. After all, both our notion of identity and its expression are linguistic as well as visual.[15]

Ulay, *Renais sense Aphorism*, 1973
From the series *Renais sense*, 1972-1975
Auto-Polaroid type 107, montage, text

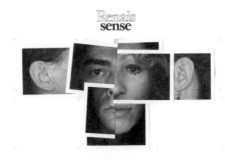

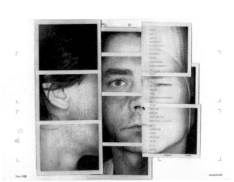

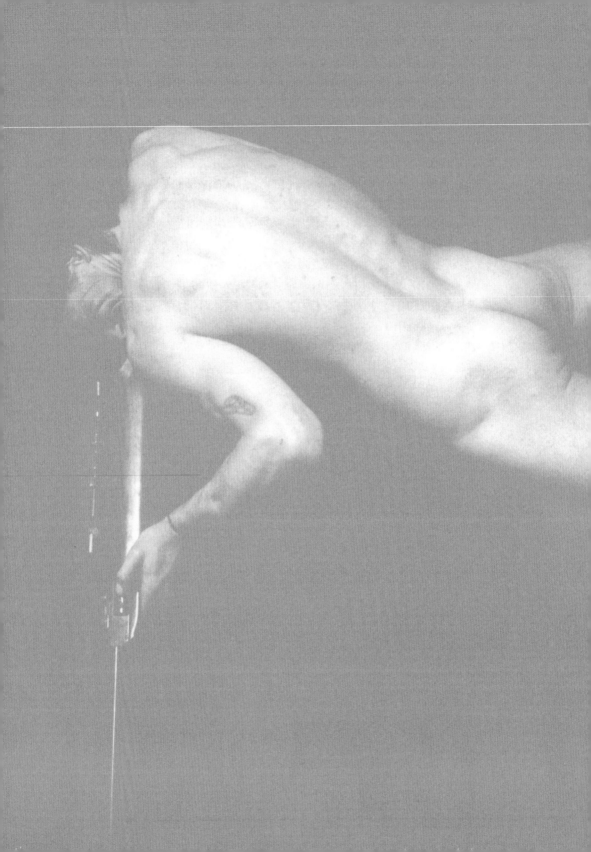

16
Rus Bojan and Cassin 2014
(note 10), p. 27.

Language is given the same role in the title *GEN.E.T.RATION ULTIMA RATIO* (1972) for one of Ulay's most extreme performances. He had this title tattooed on the skin of his left underarm and then had the piece of skin removed, conserved and framed, recording this surgical intervention in a series of Polaroid shots. In her impressive monograph on Ulay, *Whispers*, Maria Rus Bojan explains how this work has to be seen in the context of the social debates of the time on the rise of techniques of genetic manipulation in science.[16] The title refers literally to the genes that carry the DNA containing the codes of our biological identity. Generation is that of Ulay himself; in the light of the new technologies, he may be the last unmanipulated person, whose autonomy will be lost from now on. In the face of this nightmarish future, Ulay's self-mutilation is an *ultima ratio* or desperate measure to preserve the autonomy of his own body (by mutilating it and preserving a part of it).

Ulay, *GEN.E.T.RATION ULTIMA RATIO*, 1972
Polaroid type 107

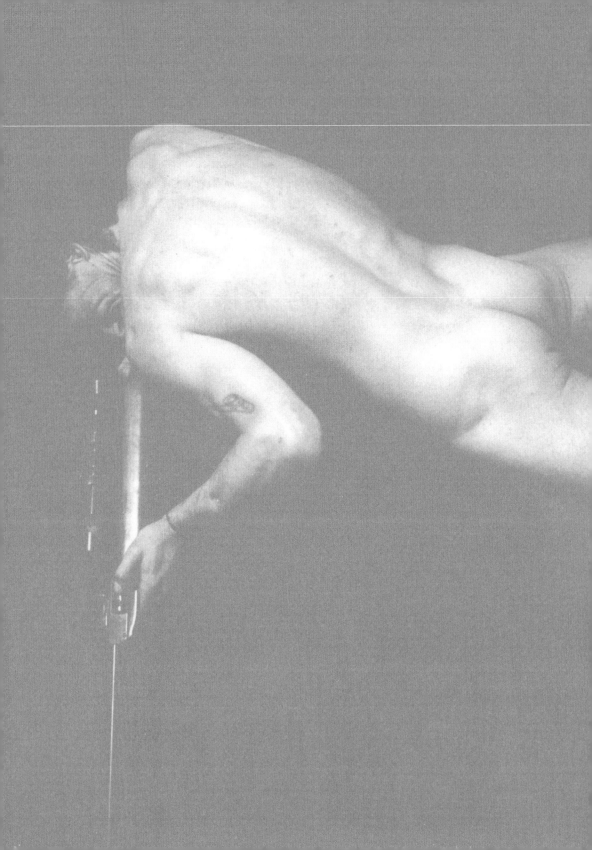

In a parallel action from 1975, Ulay separated the 'skin' of the Polaroid film from the bottom layer and the emulsion by cutting a piece of film out of the surface of the photograph and carefully preserving this fragile fragment of the Polaroid's 'body'. The parallel between photographic film, particularly Polaroid film, and human skin rears up once again. Ulay's radical fascination with the medium led not only to all kinds of experiments with the material and with different cameras, but even to placing himself physically *inside* the camera. Taking his cue from what was already known as the photogram in analogue photography, he developed a new photographic technique that he called Polagram. It forms an absolute climax in his oeuvre in combining all the main aspects of his work.

Ulay, *Untitled*, 1975
Collage

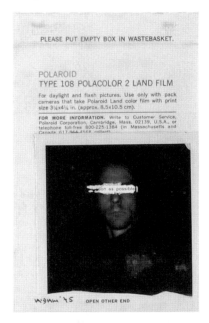

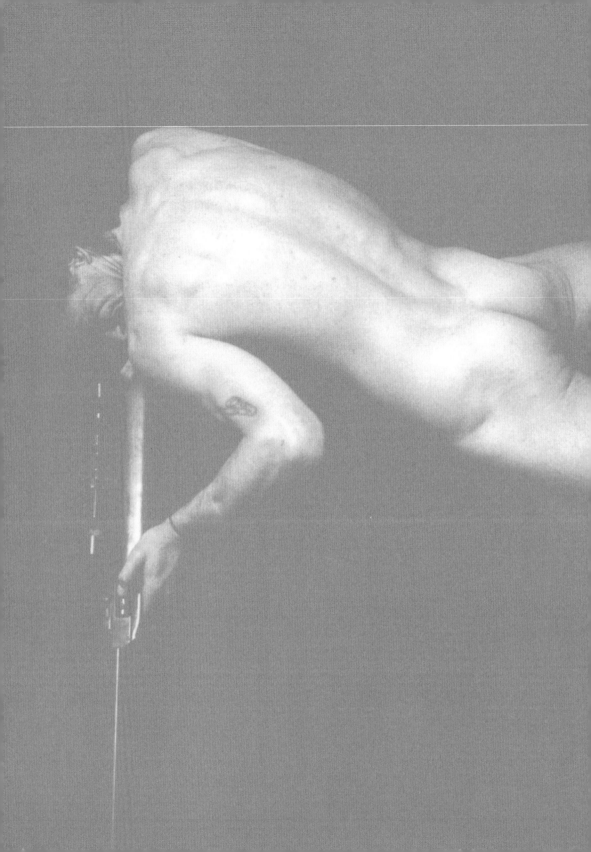

17
Rus Bojan and Cassin 2014
(note 10), pp. 28-29 and
pp. 193-196.

FOTOTOT

Ulay has not worked with Polaroid alone. His photograms made use of analogue photography technology (direct projection on photosensitive paper, followed by developing and fixing), and many performances were made with the analogue negative-positive procedure. For a proper understanding of Ulay's relation with photography, it is necessary to comment on at least one non-Polaroid work: *FOTOTOT*. This is a work that he performed in De Appel in Amsterdam in 1976. A number of exposed but not fixed, large format photographs were hung from the wall. Ulay admitted the invited public into the dark and then turned on the lights.[17] To their astonishment and dismay, the public saw the photographs turn completely black within a few minutes because of the reaction of the light-sensitive emulsion to the light. The photographs disappeared for ever. The performance was photographed, and in a second edition the public saw how the photographic documentation of the first performance turned permanently black as well.

Ulay, *FOTOTOT I - action in 2 parts*, 1976
Performance documentation from De Appel, Amsterdam, NL
Gelatin silver print

 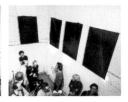

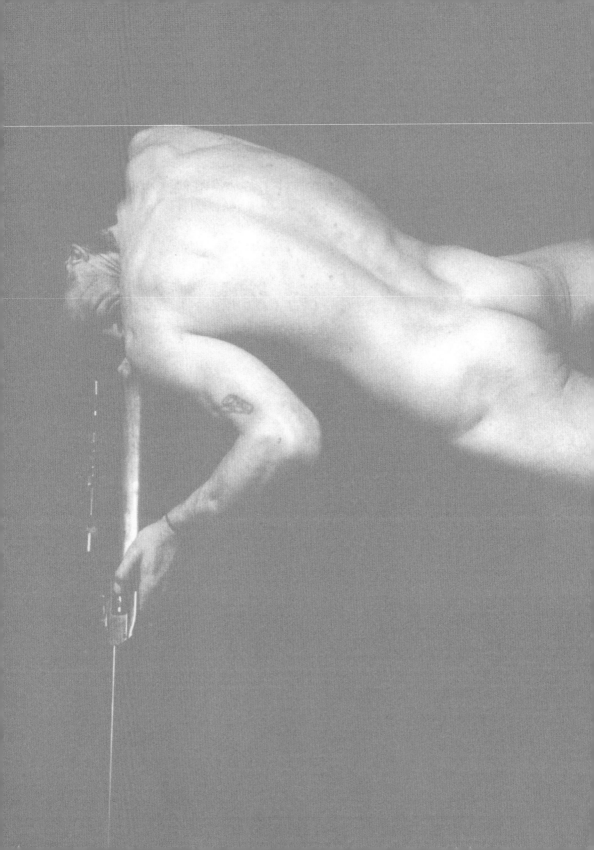

18
See note 1.

FOTOTOT (a play on the words for photo and dead) was not just a lesson in basic techniques of photography; it was also a statement on the fragility of the work of art and the autonomy of the artist, who decides on the permanence or decay of his creations. The reverse symmetry between the swallowing of the photographic images in blackness and the emergence of freshly made Polaroid prints from white in more or less the same time span was striking. For Ulay the work raised above all an essential, or even existential, question that has continued to occupy him and that becomes more significant in the light of what is to come: 'Where do the images go when they disappear?'[18]

FOTOTOT was performed just before the start of the long and intensive period in which Ulay and Marina Abramović did their famous performances. Throughout that period – down to 1989 – Ulay continued to work, in collaboration with Abramović, using Polaroid and analogue photography. He also documented all the performances, directed the corresponding film and video recordings, and made prints of the performance photographs.

Ulay and Marina Abramović
Relation in Space, 1976
Performance, XXXVII. Biennale di Venezia, Giudecca, IT

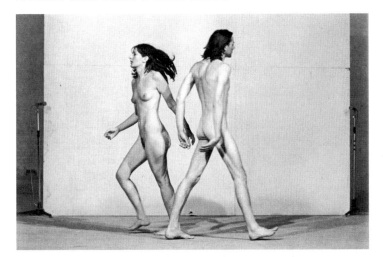

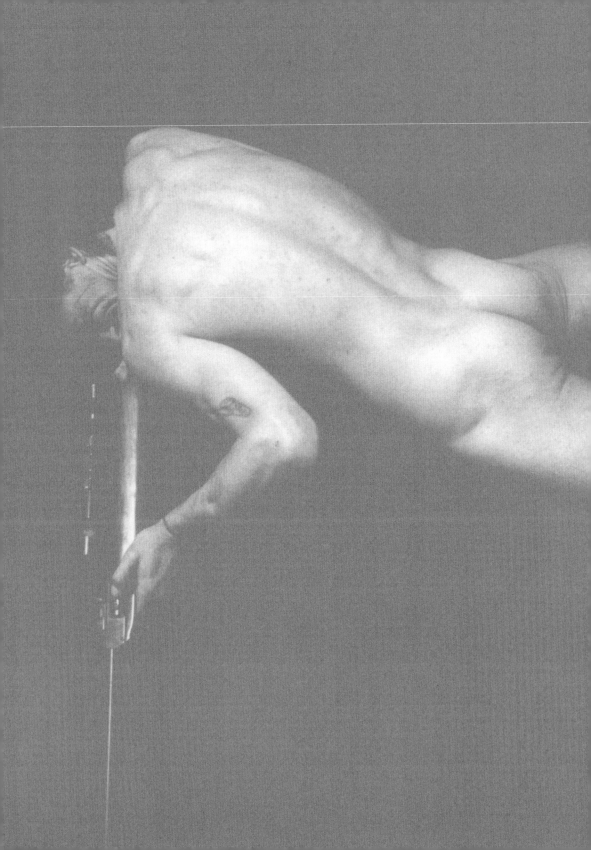

Ontology of the Image

Polaroid technology enabled Ulay to see the photographs he took of himself immediately. This possibility of immediacy is crucial and explains why he chose this medium. The regular photographic process with negatives and darkroom printing is a relatively lengthy one. An even quicker way to see an image of yourself is to look in the mirror, but that is a 1-to-1 method in which the intellectual distance is virtually reduced to zero. The image seen in the mirror is instant and even follows the viewer's movements, but it leaves no room at all for reflection. The mirror precludes intellectual reflection in this case. You can only make the self visible if it can be seen by others. So Polaroid was followed by performance, where there is a public present by definition.

Photographing yourself obviates that problem, because a photograph shows you as others see you (leaving out other abstractions due to the camera). The photograph creates the illusion of an autonomous self that is visible, tangible and conceivable for a moment. That makes the camera a suitable instrument to view yourself *as though* you were someone else. That is due to a large extent, or even entirely, to the realism of photography and Polaroid.

Ulay, *Anagrammatic Body Aphorisms*, 1974
From the series *Renais sense*
Auto-Polaroid type 107

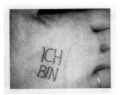 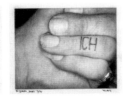

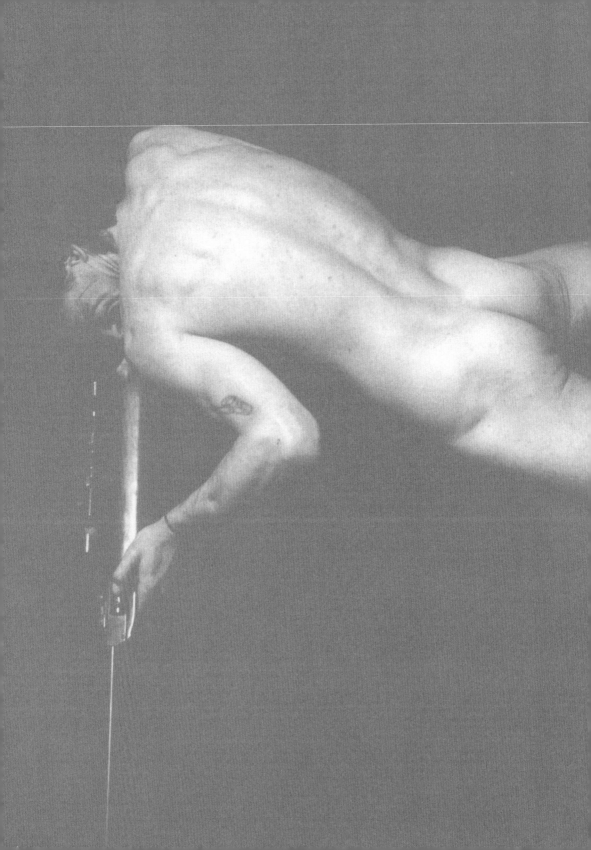

19
For example, Ulay experimented with a Polaroid camera made specially for dentists.

20
André Bazin, 'The Ontology of the Photographic Image', *Film Quarterly* 13, no. 4 (Summer 1960), pp. 4-9 (originally published as 'L'ontologie de l'image photographique', *Qu'est ce que le cinéma?* (Paris, 1958).

21
Bazin 1960 (see note 20), p. 8.

22
In the documentary *Project Cancer: Ulay's Journal from November to November.* Director: Damjan Kozole, 2013, 91 min.

Polaroid technology reduces the distance between image and reality. The image virtually coincides with reality in a way that enhances its magic and makes the photographed object present again: it is re-presented. The effect is optimal when the representation is life size, which explains Ulay's preference for a scale of 1:1. For example, this led him to work with medical Polaroid cameras that reproduce directly on a scale of 1:1.[19] In this connection Ulay refers to the lack of grain in Polaroid film and the perfection of the print, resulting in a visually perfect reproduction. He also refers to André Bazin's theory of the ontology of the photographic image.[20] This French film critic argued that only the camera lens can give us an image that satisfies the deep human need to replace tangible reality by something that coincides with it: 'The photographic image is the object itself, the object freed from the conditions of time and space that govern it. No matter how fuzzy, distorted, or discoloured, no matter how lacking in documentary value the image may be, it shares, by virtue of the very process of its becoming, the being of the model of which it is the reproduction: it *is* the model' (emphasis added).[21]

The representation or reappearance of the body in the form of an image can thus be connected in a very direct way with its actual existence. Body and representation coincide. Elsewhere in his essay Bazin sees the photograph as 'a hallucination in the form of a fact'. Bazin's remark on a 'deep human need' explains how Ulay's work can express a strong desire. In the film *Project Cancer*, the director of the Tate Modern, Chris Dercon, rightly states that Ulay's work is not effective but affective. It radiates desire, but it desires something from the viewer just as much.[22]

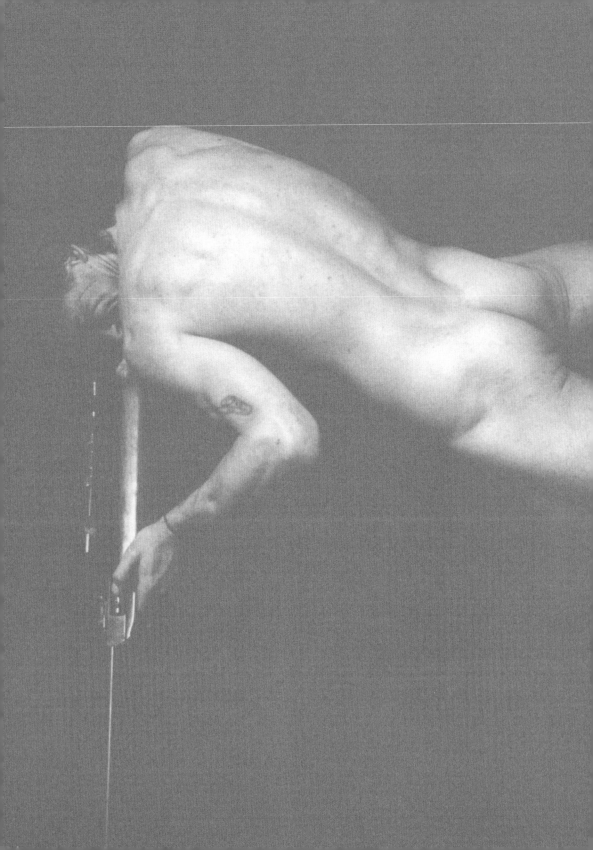

23
Ulay / what is that thing called photography? (Landgraaf/Heerlen, 2000), n.pag.

24
Vilém Flusser, *Für eine Philosophie der Fotografie* (Göttingen, 1983) (English edition: *Towards a philosophy of photography* (London, 2000)).

Of course, between reality and the artist there is the medium, the camera, which mediates and, as Bazin writes, has its own programme, in other words, a fixed operation and pre-programmed effect on the result. So Ulay's quest for and questioning of his identity cannot go without an exploration of the working and effect of the medium used, each as thorough and radical as the other. *what is that thing called photography?* is the title of the book – actually a reproduction of a notebook – filled with sketches, notes and photographs in which he explores, analyses, clarifies and comments on the working or programme of the medium and elaborates his ideas in a sketchy way.[23] Recurrent themes within a diverse range of ideas are the camera and the way in which it abstracts reality. But the main role is that of the body as medium, which relates to the camera and to the images produced by the camera both spatially and through brain perception. The artist operates in the force-field created by the interaction of these three and searches for possibilities, limits and meanings.

Publication *Ulay / what is that thing called photography*, Artists' Books Johan Deumens, (Landgraaf/Heerlen, 2000)

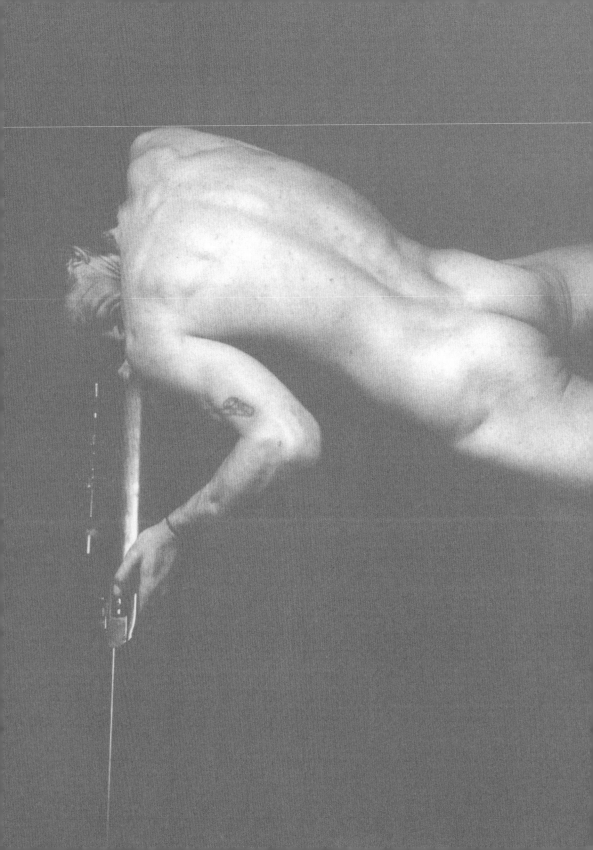

25
Flusser 1983 (note 24),
p. 21.

Ulay sketches the many relations and possibilities in the book and makes connections with his own work, the history and theory of photography and visual culture. The words 'for a philosophy of photography' are written roughly halfway through the book. It is a direct allusion to an influential essay by Vilém Flusser from 1983.[24] This Czech media philosopher, who worked for a long time at the university of São Paulo and was only discovered late in Europe, sees the technological and what he calls 'post-historical' medium as an important actor in the historical revolution in which images are no longer deployed to change the world, but to change the meaning of the world. The old incantatory ritual connected with images has been replaced in the modern era by a self-conscious way of dealing with them, while the 'myth of images' has been replaced by the technological 'programme'. Flusser uses the model input>black box>output here. When he talks about the photographic process, he explains that the photographer is more inextricably entwined with his camera *by definition* in a much more intense way than any ordinary user with his tool.[25] The words could have been written for Ulay.

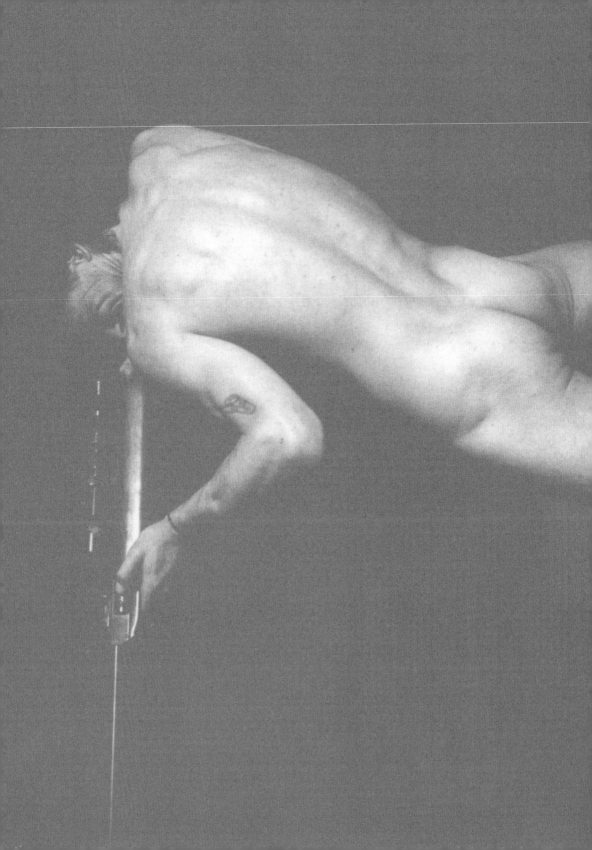

Synthesis

Ulay's desire to explore the boundaries of the medium and to break through its programme eventually led to working *inside* Flusser's black box. The large 40 × 80 inch Polaroid camera in Boston made that possible. After a very meticulous and precise preparation, Ulay, with the help of assistants, stepped inside the black box of the camera and sketched an image on the Polaroid negative with small lamps; he would only be able to see it after it had been developed. The enormous size of the negative enabled him to relate to it with his own body in a 1:1 ratio – body and image coincided. It was a radical action that disrupted the programme of the camera and reduced the operation of photography to its bare essence: there could be no getting any closer than this. The artist *had become* his medium, input and output were one. When we look at the mysterious and overwhelming result with the title – how could it be otherwise? – *Self-Portrait* (1990), we see how from the darkness of the black box Ulay offers us a hand through which a gentle, pinkish-red light shines.

Ulay, *Self-Portrait*, 1990 (detail)
Polagram, Boston Studio, USA

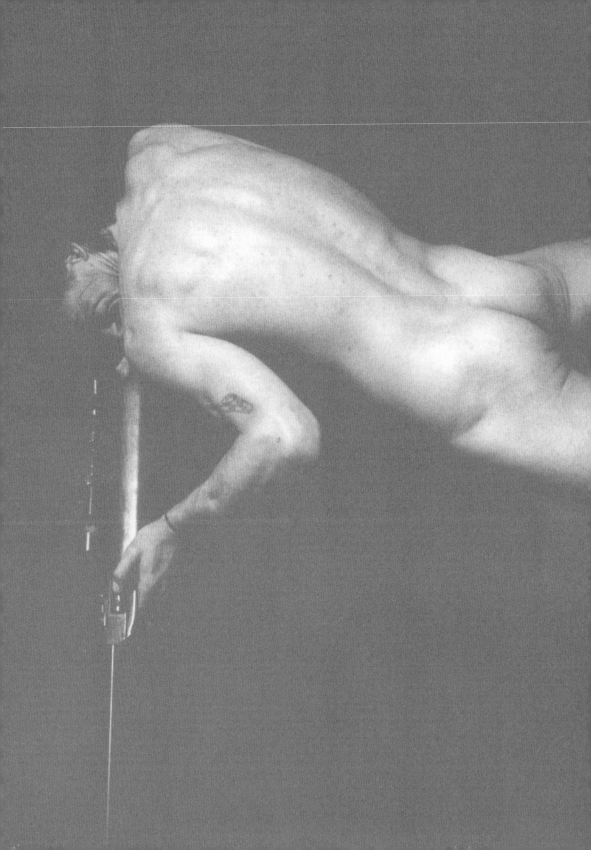

EiS VIEL VER

LÄNDERNDES AUTOUNGLÜCK 4)

Ulay, *Soliloquy*, 19
Polaroid type 108,

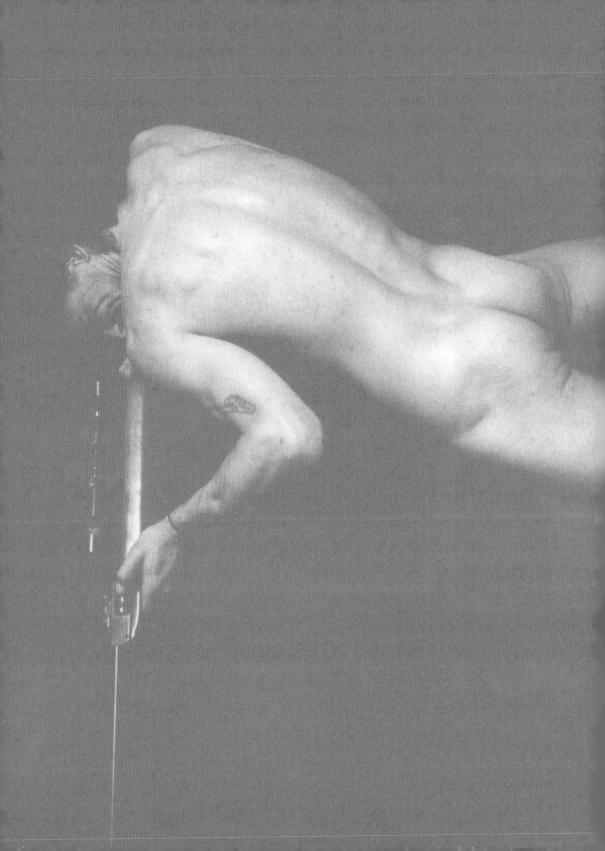

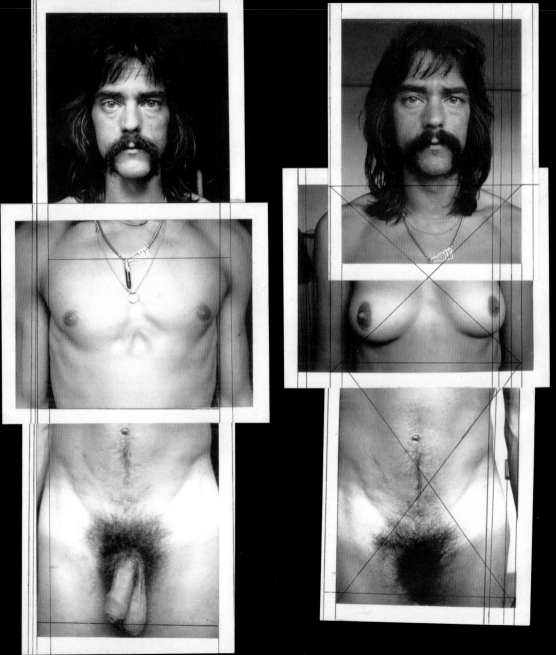

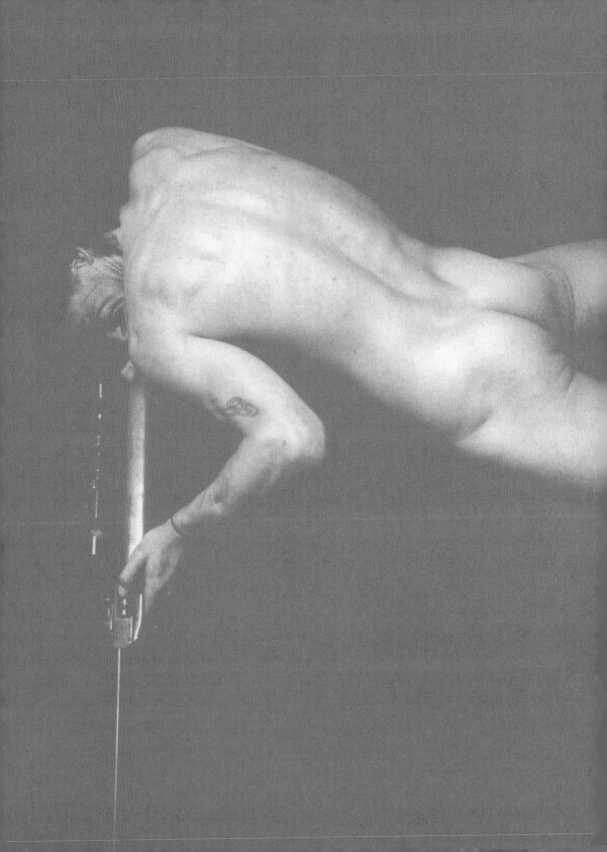

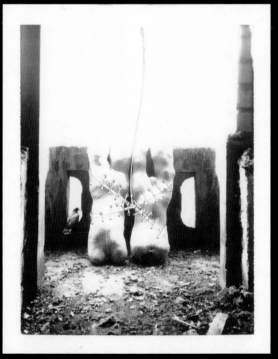

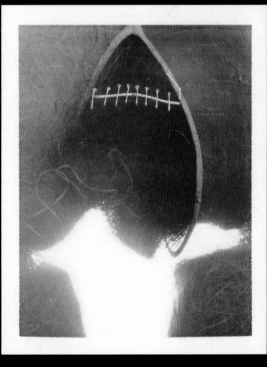

Ulay, Jürgen Klauke and friend
together for the book *Ich und Ich*, 1970
Polaroid type 58

Ulay, *Ich und Ich*, 1970
Two images for the book in
collaboration with Jürgen Klauke
Polaroid type 57

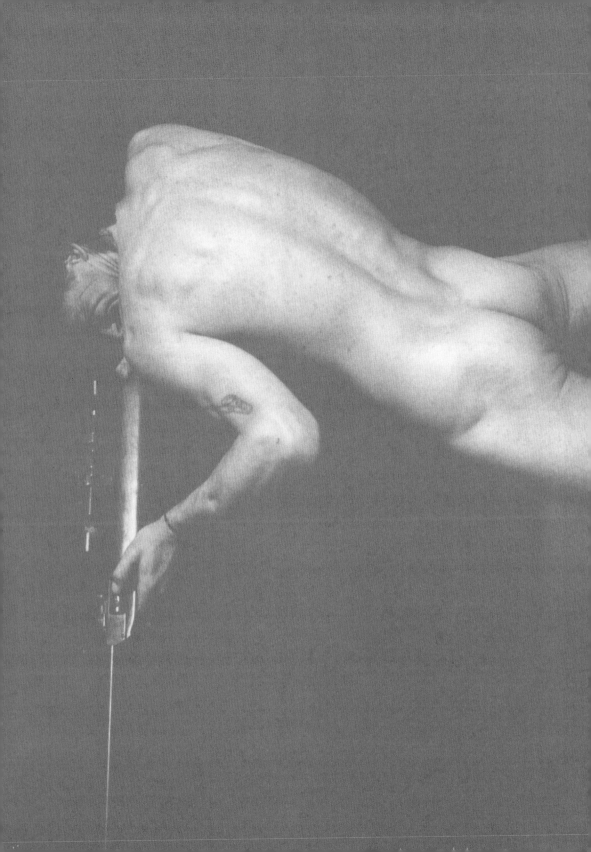

22.25 August. 1978

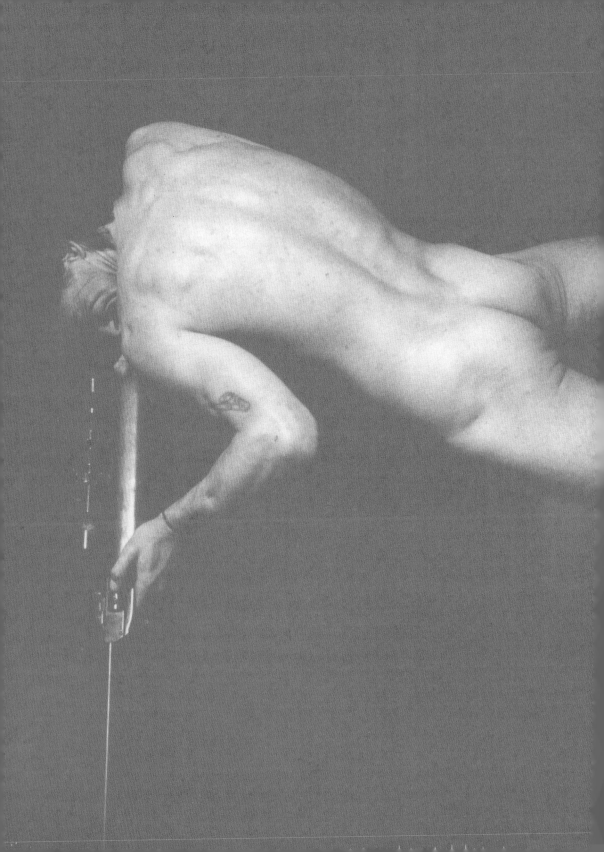

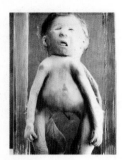

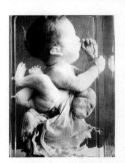

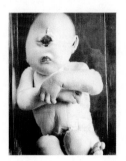

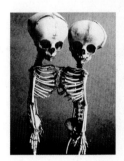

Renais-sense L.

^ >
Ulay, *Renais sense*, loose paper
edition for Galerie Seriaal, 1970

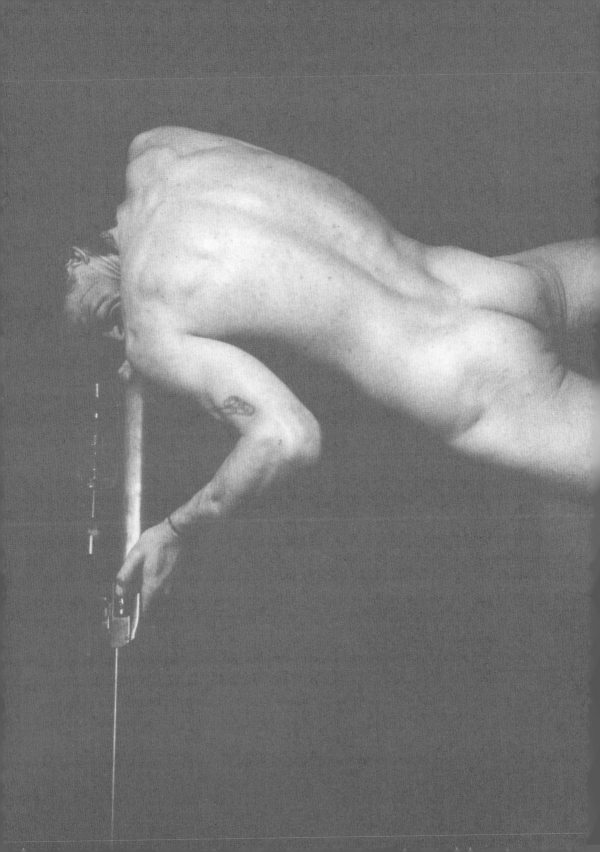

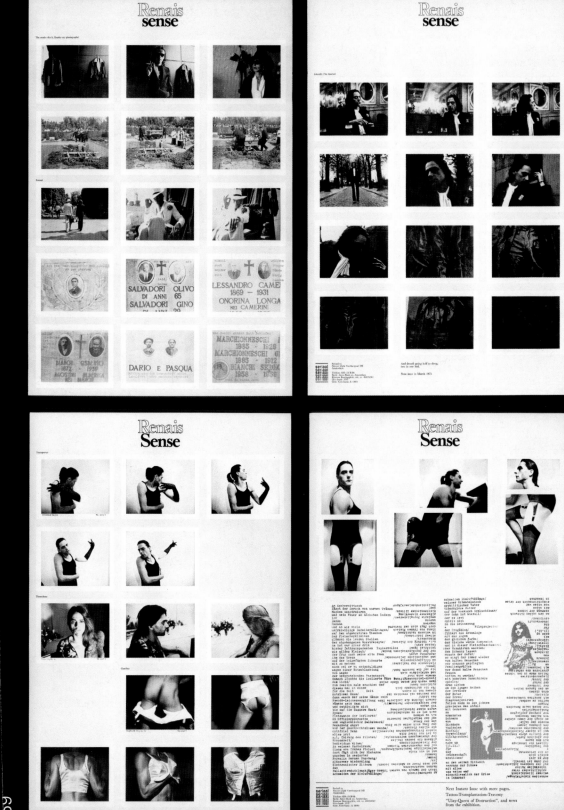

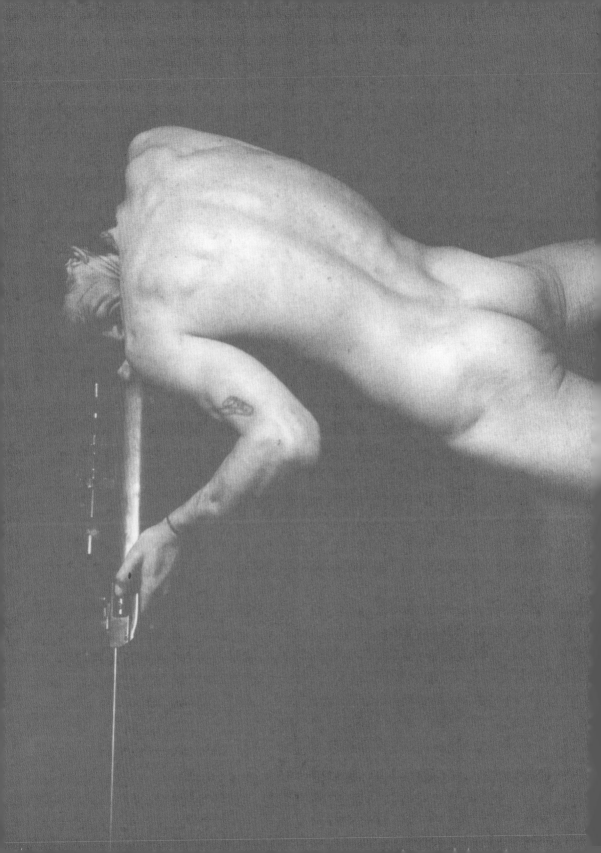

BLOEMENDAAL 73

Ulay, *Bloemendaal Soliloquy*, 1973
From the series *Renais sense*
Auto-Polaroid type 107

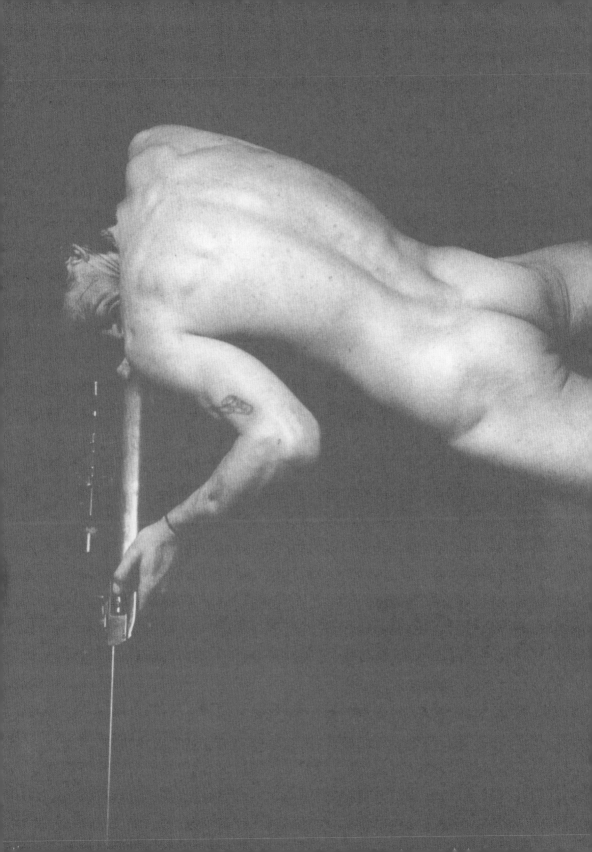

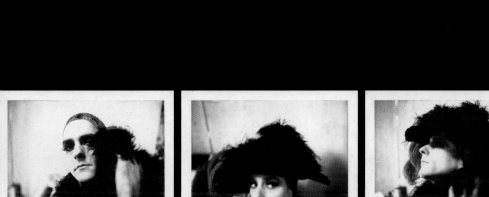
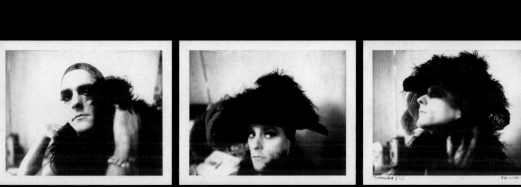
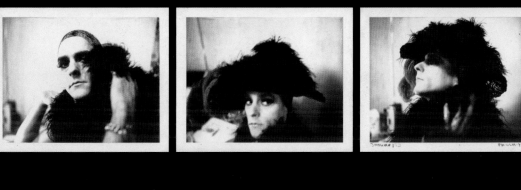

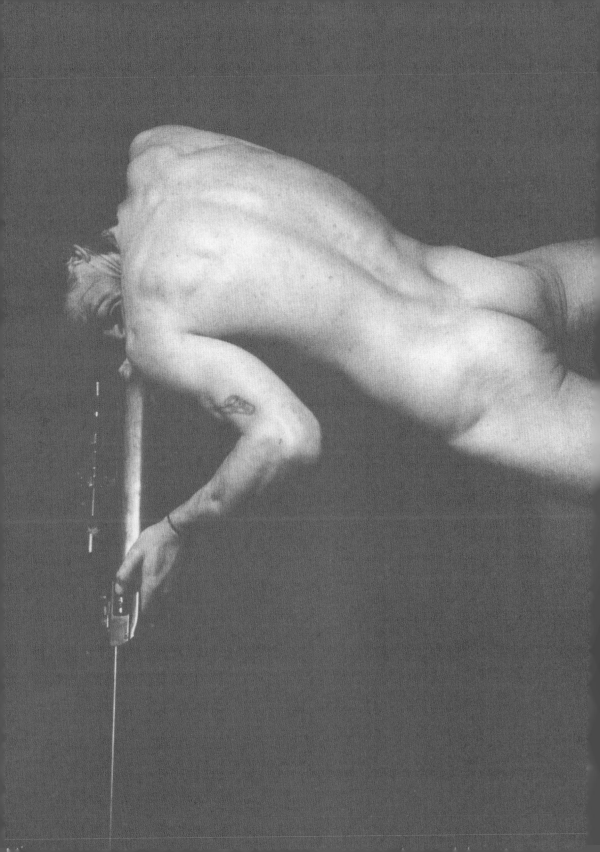

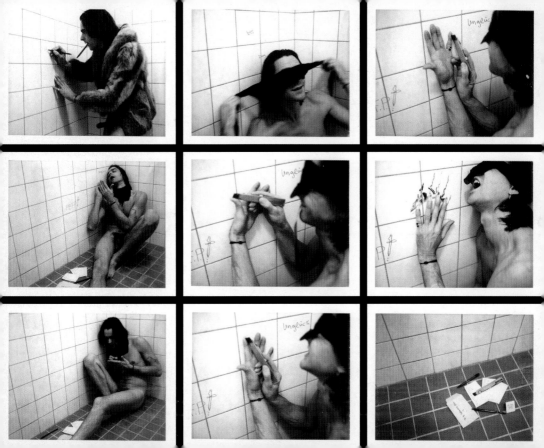

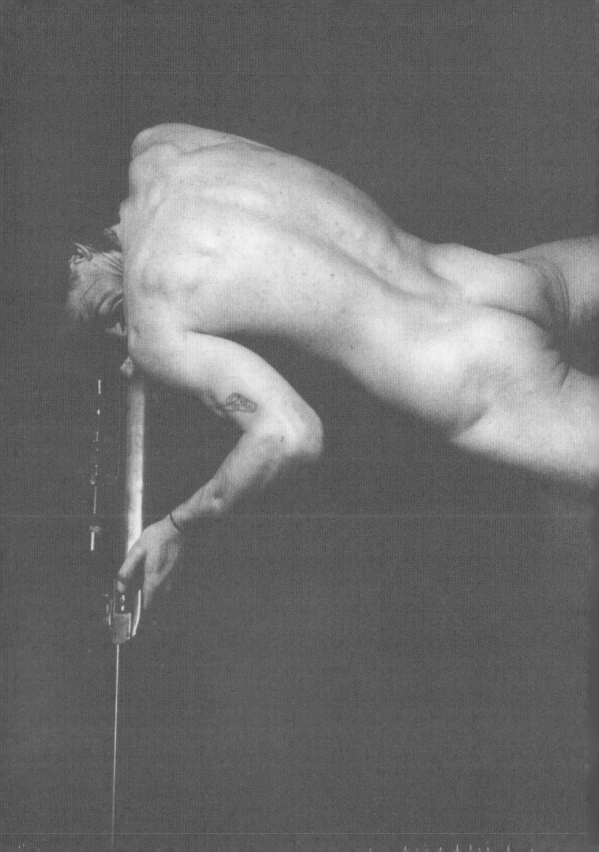

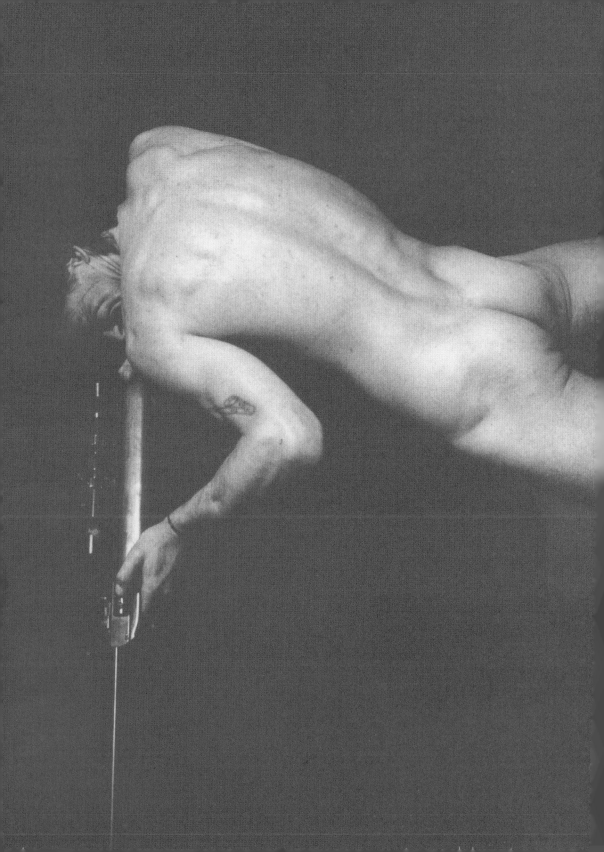

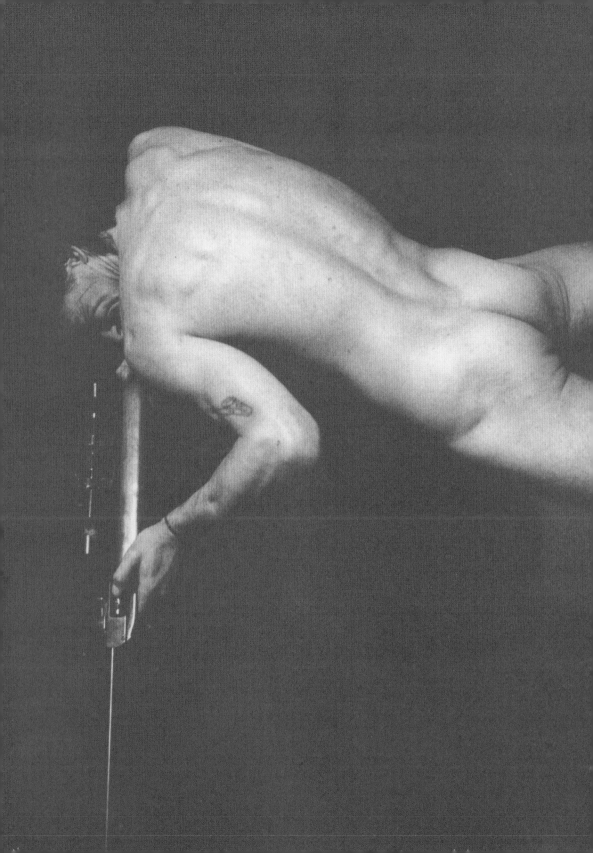

Ulay, *New York Afro-American
Homeless*, 1992
From the series *Can't Beat the
Feeling - Long Playing Record*
Polaroid/Polacolor, New York Studio

＞

Ulay, *Untitled*, 1993
6 Polagrams, Boston Studio, USA

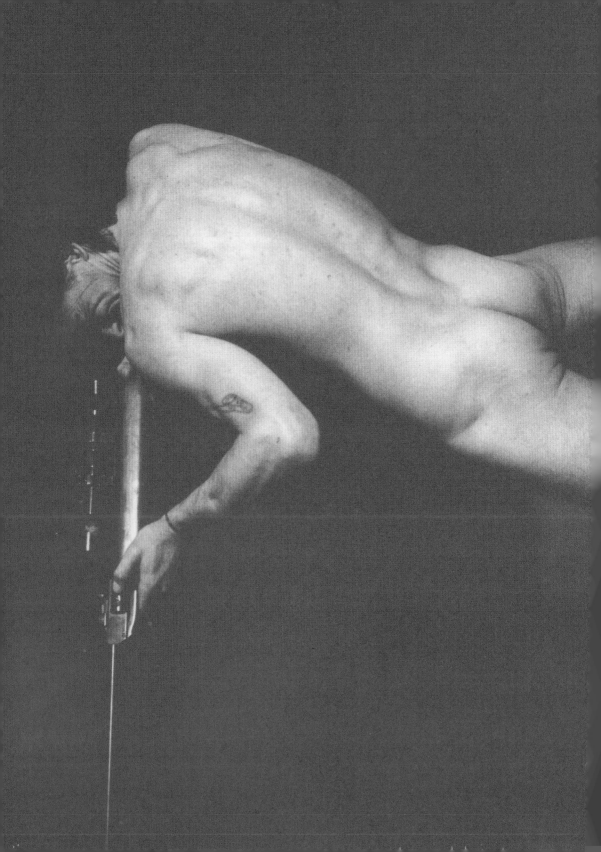

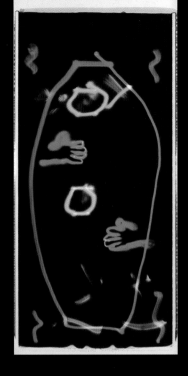

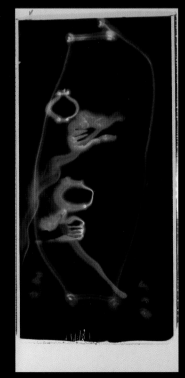
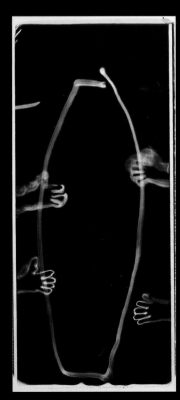
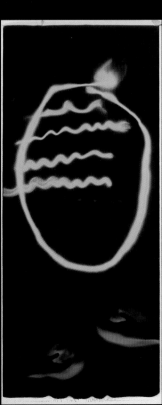

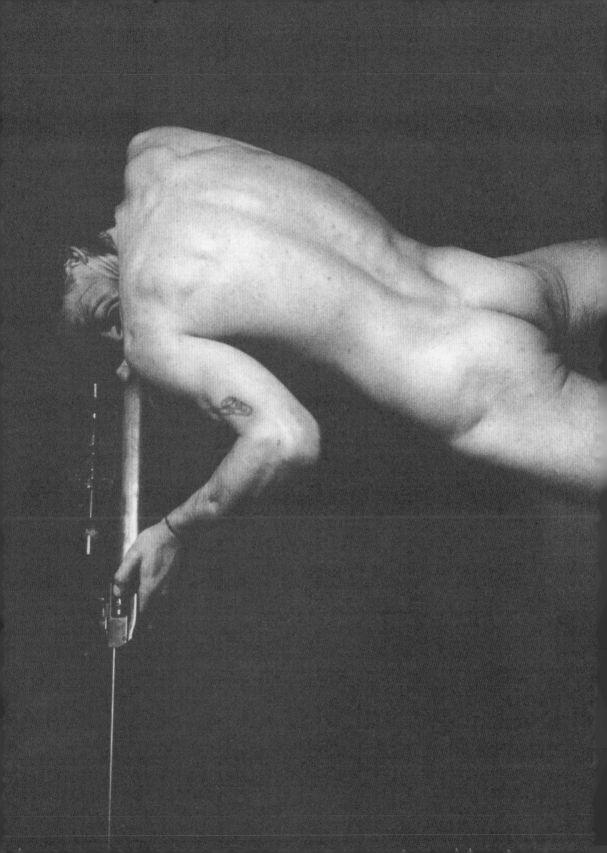

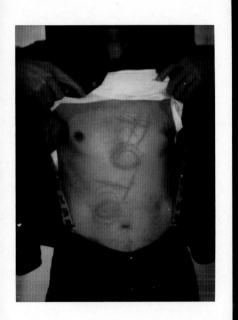

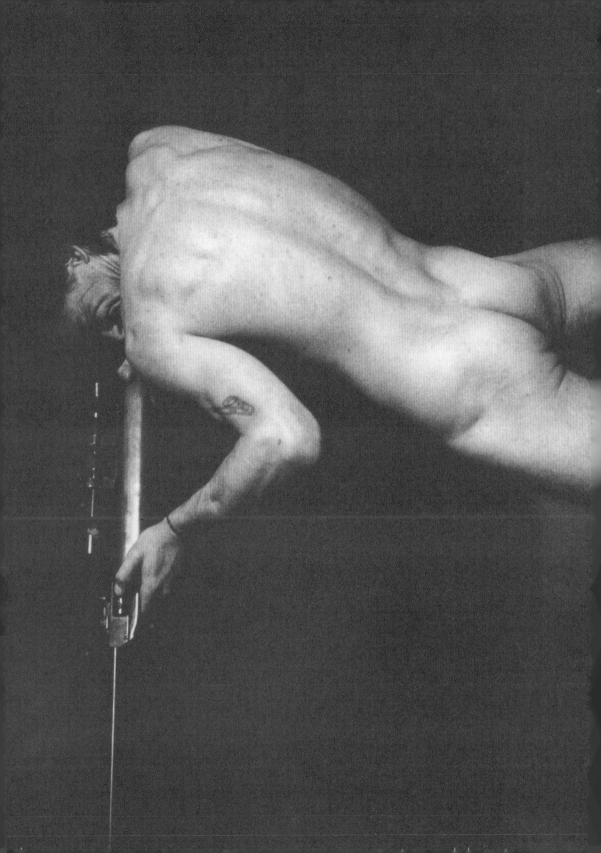

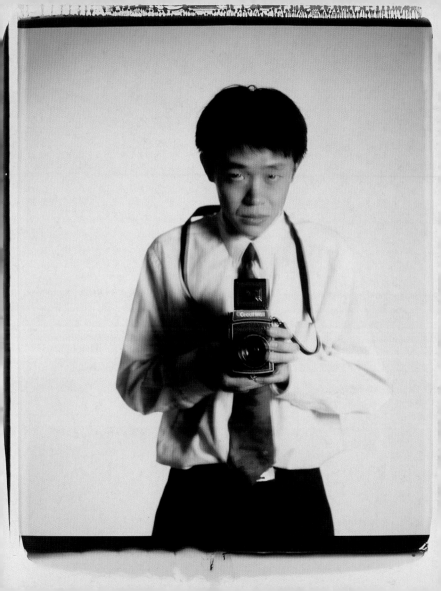

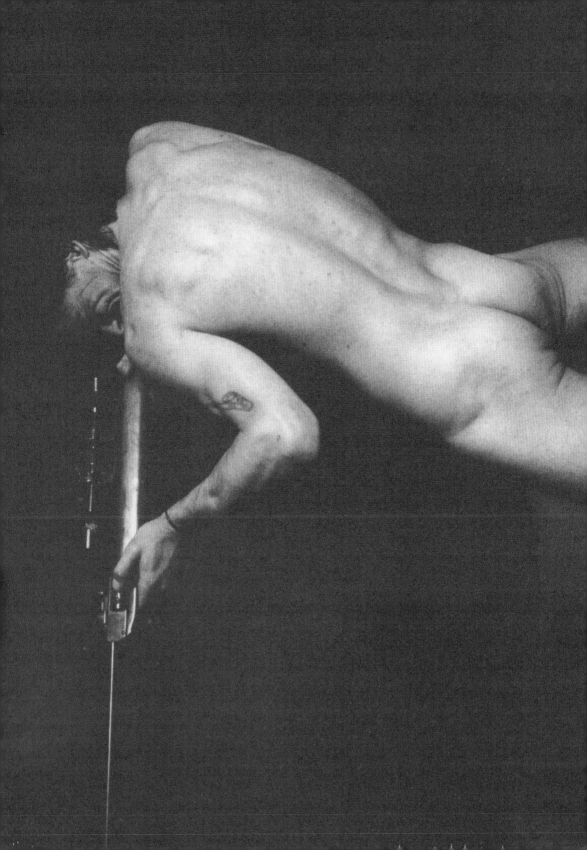

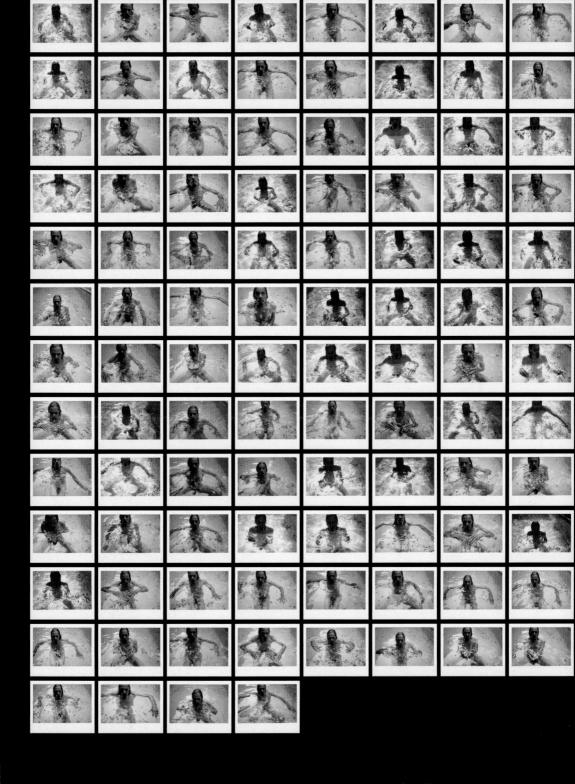

Ulay, *JOY*, 2015
A series of 100 unique Polaroids,
Fujifilm Instax Wide
Especially made for Rabobank

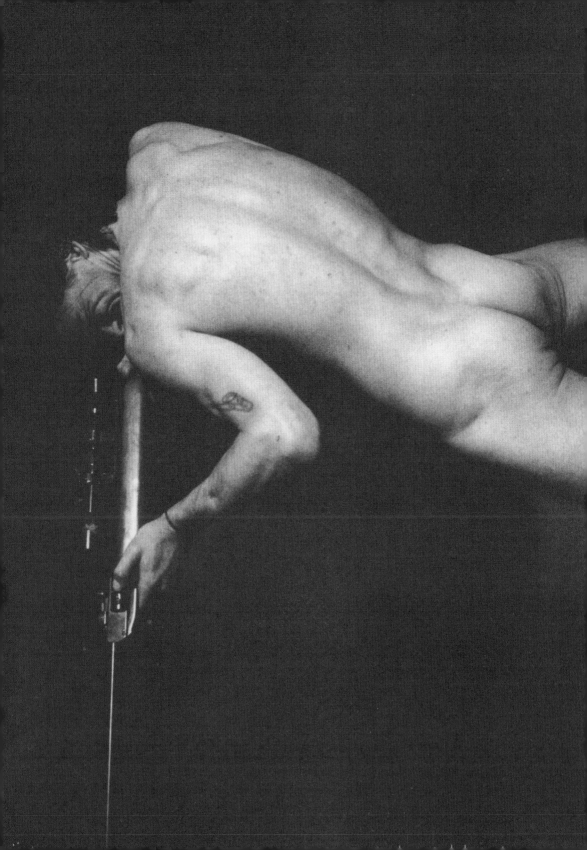

Polaroid and Ulay

Katrin Pietsch

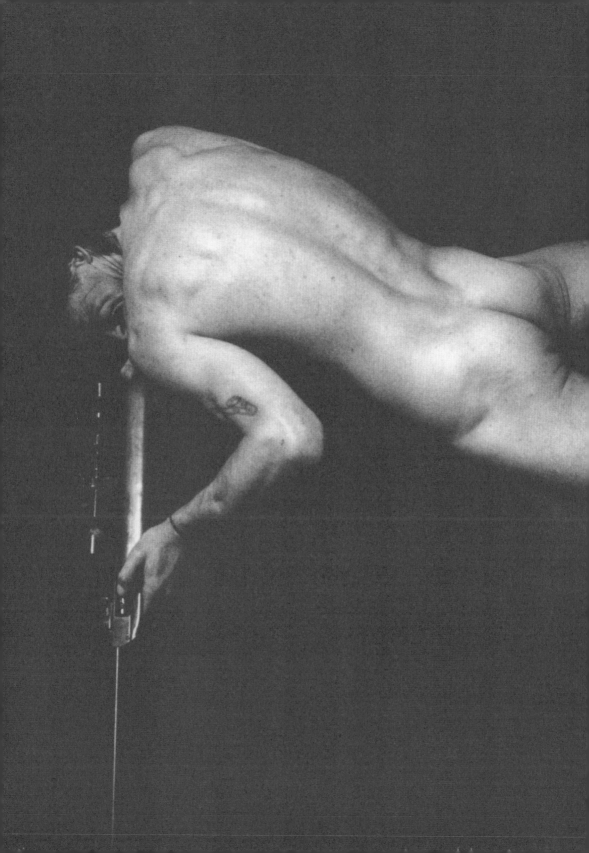

Polaroid and its
Technical Innovation

As no other company before it, Polaroid combined technical revolution with unique marketing and thus not only created new products for the photography market, but a whole myth. The name 'Polaroid' today stands for a whole group of photographic processes, summarized under the term 'instant photography'. One-step-photography that delivers a positive print instantly, on the spot.

The story of the company, its technical inventions and the influence it had on the development of photography as an art form is surely unique.

The company Polaroid was founded by Edwin H. Land in Cambridge, Massachusetts in 1937 as an expansion of his earlier, smaller company 'Land-Wheelwright-Laboratories'. The name Polaroid has its origins in the words 'polarization' and 'celluloid' and goes back to Land's first patent. In 1933, his invention of a polarization filter foil for sunglasses and car headlights was finally honoured. The filter eliminated the disturbing reflection of the lights. Through polarization light waves can be aligned in one direction. Celluloid (cellulose nitrate) was the base material of Land's very first filter foils. The polarized sunglasses were the very first product sold by Polaroid.

World War II made the start-up grow, because of the high numbers of sunglasses that were sold to the military. Already back in those early days, Polaroid had a department that invested in scientific research and from there product development was broadened. One big project was the study of 3D film technology. From there, Polaroid got into photography and developed stereoscopic imaging for the military. This brought the company much financial success and formed the basis for the later research into instant photography, which didn't pay off immediately.

In 1943, the first experiments in that field began, again driven by the needs of the military industry.

Polaroid camera SX-70

Film still made by the Eames Office to advertise the new Polaroid SX-70, 1972

In 1947, Land was able to present his first instant camera, loaded with black-and-white film. The 'colour' was more like sepia and the prints had to be stabilized by adding varnish afterwards, otherwise they would discolour soon after having been made. This was due to oxidation of residual chemicals on the surface.

In 1950, the first film in real black-and-white as opposed to sepia came on the market. Still, the prints had to be treated with varnish, which made it not really one-step-photography.

In 1958, there was the Polaroid sheet film, a package of negative, positive and development agent all in one, whereas before the films were on a roll and developed inside the camera. The first colour film, the Polacolor film, commercialized in 1963, also had to be coated directly after development. That year, Polaroid also launched its first black-and-white pack film, which contained 8 to 10 sheet films per pack. Polaroid managed to overcome the need to coat the prints shortly after. The development reached its peak when Polaroid introduced its SX-70 system on the market in 1972. It was the very first instant integral colour film. Land had reached his

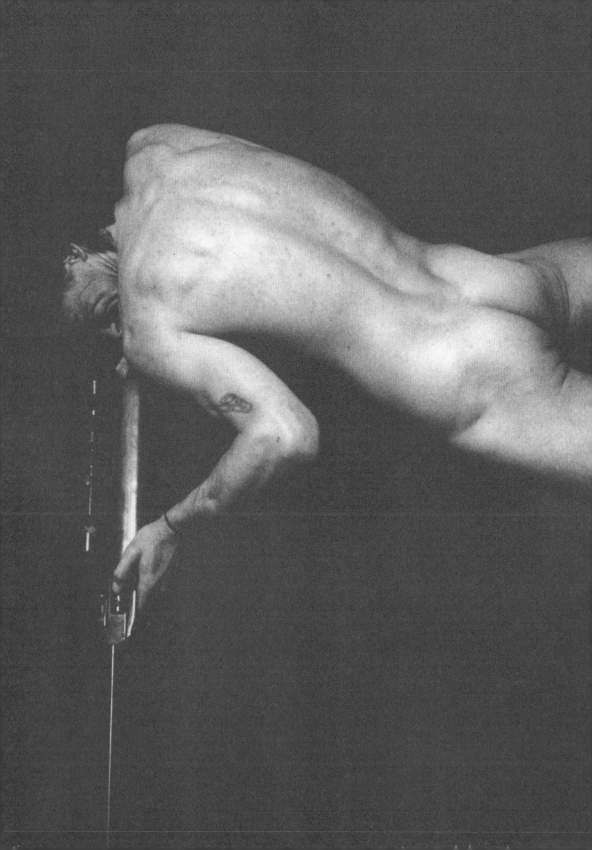

ultimate goal of creating real one-step-photography. In 1976, Polaroid revolutionized large format photography by creating a camera for 20 × 24 inch and 40 × 80 inch prints.

Company legend has it that Land developed the first camera to meet his daughter's wish for immediately seeing the pictures they had just taken. But being an inventor as much as a marketing genius from the very beginning, Land once more showed his ability to meet the needs of the financiers to be able to work on his revolutionary ideas for the consumer market.

After many successful years, the advent of digital photography struck the Polaroid company too and forced them to declare bankruptcy in 2001. Several attempts were made to keep the business going; despite these efforts the production of instant film ended in 2008.

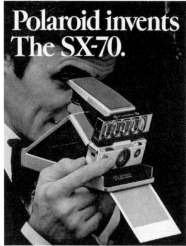

Polaroid advertisement
for the SX-70, 1974

Polaroid advertisement
for the SX-70, 1977

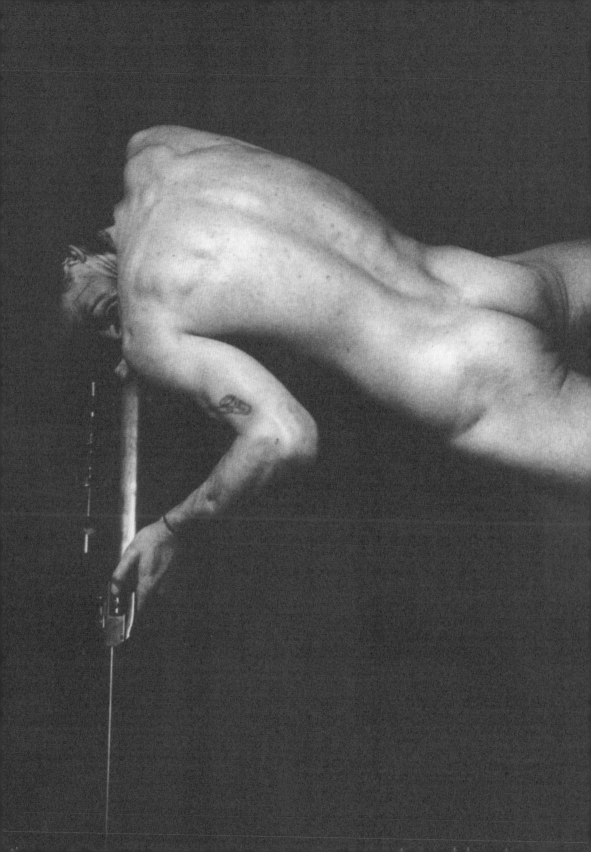

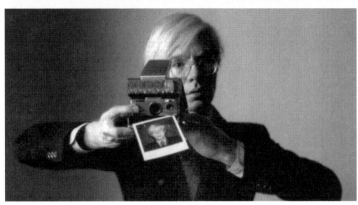

Andy Warhol with Camera, 1974
Polaroid camera SX-70, Polaroid type 105
Photo by Oliviero Toscani

Polaroid and the Artist Support Program

Whereas Kodak mainly focused on the lower end of the consumer market, Land was interested in artistic photography as well, from the early days on. His commercial success gave him room to follow that ambition. To this end he developed the Artist Support Program (sometimes also referred to as the Artist Consultancy Program) and provided artists with materials and studios so that they could test the Polaroid products and collaborate in improving them.

Polaroid's Artist Support Program had its roots in the friendship of Edwin H. Land and Ansel Adams, who had first met each other in 1948. That very year, Land hired Adams to test his cameras and film material. In return, Adams would report on his findings, which formed the basis for further attempts for improvement by the Polaroid engineers. Adams was followed by many fellow photographers and soon enough he coordinated the Artist Support Program that Polaroid ran for about 30 years.

Land and Adams found each other in their aim to establish Photography as a Fine Art form. That wasn't easy in the beginning, because the first Polaroid films were of inferior quality and artists weren't very keen on using them. With the constant improvement over the years, both felt that the excellent quality of the Polaroid material was highly suitable to be used in art. Especially the ready-made character of instant photography attracted artists more than it did photographers.

Initially, instant photography was mainly intended as a medium for amateurs, because no darkroom or chemistry knowledge was necessary to produce photographic prints. Soon enough, however, especially the impossibility to manipulate the image technically except at the very moment when you took the photograph made it the perfect medium for some artists.

To be able to set the standard the Polaroid films had to meet, Adams started building the Library Collection with examples of works by the best photographers at the time. It was quite an expensive way to create a reference library that the instant films had to compete with.

Already in the 1950s, Polaroid established a deal with young photographers who could use and test cameras and material and in exchange gave their best works to the company. Over the years, quite an impressive collection was thus formed, with some of the most iconic Polaroid photographs we know today. The collection consisted of two parts: the International Polaroid Collection, housed in Amsterdam and the Polaroid Collection in Cambridge, Massachusetts, Polaroids home base. The general tendency in art in the 1970s to experiment with technique and aesthetics suited the self-image of Polaroid as an

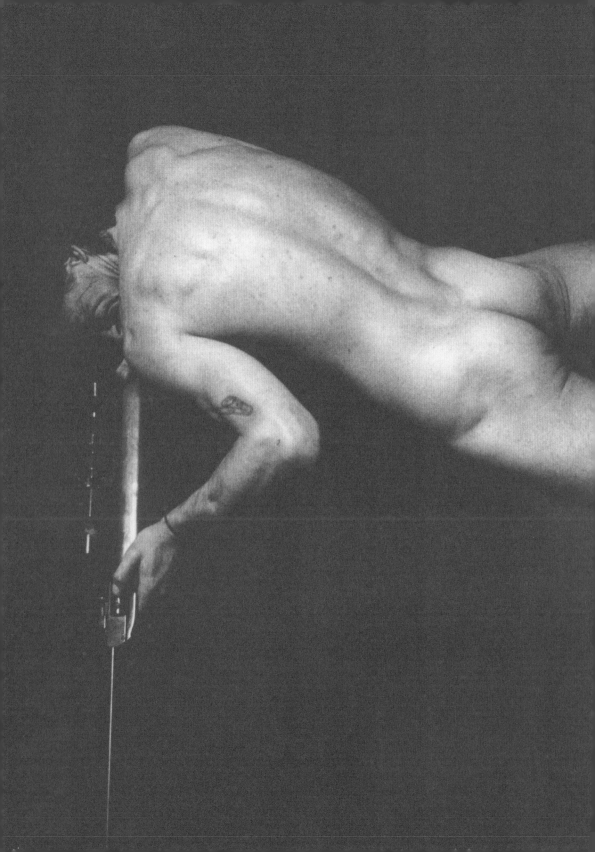

innovative, creative and inventive company very well. During the last twenty years of Polaroid, mainly the work done in the 20 × 24 studios by artists and photographers formed the most important source for the collection. After the bankruptcy of Polaroid, the Polaroid Collection did house works of nearly 2,000 photographers and held about 23,000 photographs.[1]

In 2009, the European part of the collection was purchased at an auction by WestLicht Galerie and is now based in Vienna. Most of the American part of the collection was sold in single pieces that therefore lost their original context, much to the protest of many artists and art historians.

Polaroid camera 180

Polaroid camera 190

Polaroid and Ulay

Ulay: 'I am not a photographer, because I don't have the patience.'

Polaroid material did suit Ulay's temperament and way of working best: immediate, instant, direct, 1:1 true to size, analogue, straightforward and not easily manipulated. Unique. He calls Polaroid the Rolls Royce of Photography. Ulay started to work as a Polaroid consultant in 1970 and continued his consultancy till 1975. He was provided with different cameras and film material. In exchange he made, for example, photographs for a publication presenting five different cities seen by his Polaroid camera.[2]

In 1972, he started to use the material to create his first Auto-Polaroids.

In 1976, the *FOTOTOT* event rounds up his first photography phase and marks the starting point of the purely performative work.

Ulay used many different sorts of Polaroid material in his work. By far the most favoured were the films for the handheld model SX-70 (integral film) and the type 107 (black-and-white peel-apart) and 108 (colour peel-apart). Those types he used for his very intimate work, where he operated everything himself. Besides the SX-70, his most favoured cameras for these works were the Polaroid 180 and the 190 (which had a superior Zeiss optic system). He also used a Polaroid dental camera, which was built for small real 1:1 photographs especially for dentist' purposes. Later, when Ulay brought his performance back to photography, he started using the larger Polaroid formats, the 20 × 24 inch camera and the biggest, the 40 × 80 inch camera. He would return to both types several times in his career, marking different phases in his work and life and highlighting his ideas about 'performative photography'.

1
Steve Crist and Barbara Hitchcock, *The Polaroid Book: Selections from the Polaroid Collections of Photography* (Cologne, 2008), p. 17.

2
Scott Miller (ed.), *Uwe's Polaroid Pictures of 5 Cities: Photographed and Narrated by Uwe Laysiepen* (Amsterdam, 1971).

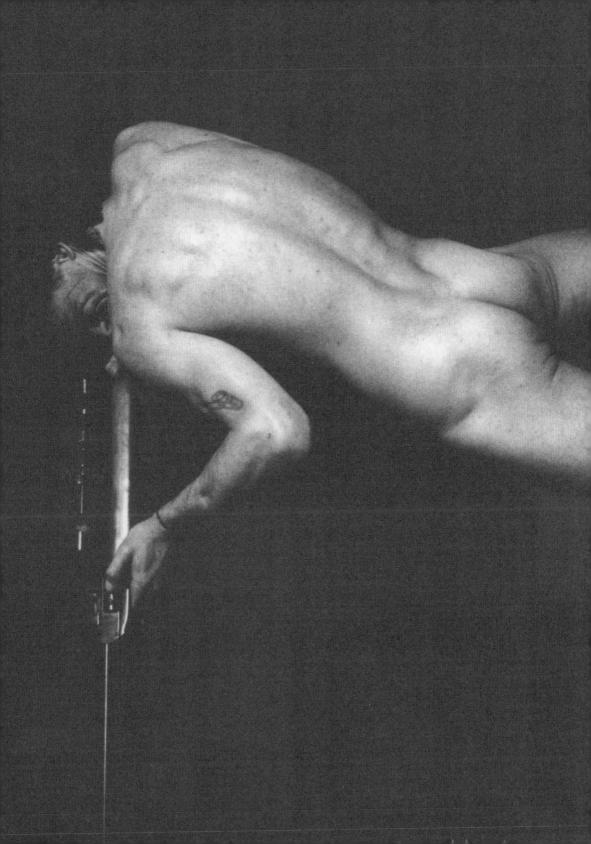

Polaroid - The Photographic Object:
Technical Perfection
and Chemical Vulnerability

Polaroid - The Process

In order to grasp the technical
ingenuity of the Polaroid process in
combination with its chemical vulner-
ability it is essential to under-
stand some of the principles of the
material and how it works.

There are two different types of
film within the whole range of
Polaroid materials: the peel-apart
films and the integral films.

Peel-apart Film

The first type works with two parts.
One being the negative, which is
exposed to light and then brought
together with the second part,
the image receiving paper, where the
positive will appear. To make that
happen, after exposure both layers
are brought in direct contact with
each other. In between both layers,
a capsule with developing reagent
called the pod is sandwiched. The
whole package runs through a system
of evenly pressing steal rollers,
which ruptures the aluminium foil
of the pod and squeezes the chemicals
between the two layers. As soon as
the viscous solution is spread
over the whole surface, development
of the negative will take place and
at the same time the transfer of
the positive image to the receiving
paper. After sufficient development -
which takes about 60 to 90 seconds
- the negative can be peeled off and
the positive image is ready to dry.

With the handheld format cameras
the movement through the rollers
is done by pulling the package
by hand, while with the large formats
(20 × 24 inch and 40 × 80 inch)
a motor drives the roller system.
The chemical development consists
of a whole bunch of very complex
synchronized steps to let every part
perform its action at exactly the
right moment. Most of the research
at Polaroid went into the creation
of the pod. It had to have the right
components in just the right amount
and viscosity to get spread perfectly
even between the two layers. The
entire surface had to be covered with-
out leaving too much excess of the

Edwin H. Land presenting the first
Polaroid peel-apart film, 1947

Life goes by so fast.
Stop for a moment
and take a look at it.

Polaroid advertisement for the
peel-apart film, 1967

chemicals, resulting in a nearly dry
print. In fact the process consists
of a photographic step, when the
negative is exposed and developed and
a printing step, when the positive
is produced.

Whereas this whole darkroom in
one film package already is a small
miracle in the black-and-white mate-
rial, it certainly is incredible
in the colour material. The Polaroid
colour processes are so-called dye
developer or dye diffusion processes.
As in many other analogue photo-
graphs, the colours are formed in
three layers, each sensitive to
one colour. But the negative of the

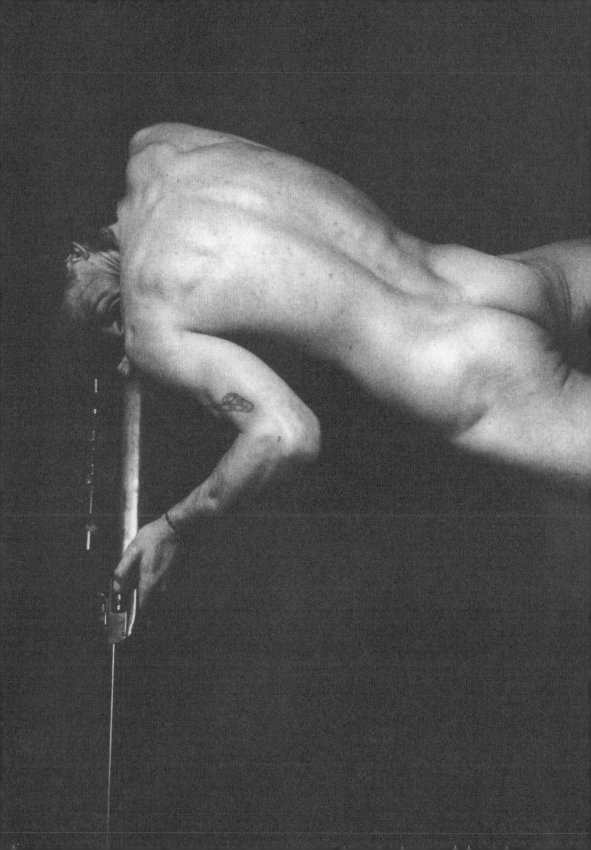

peel-apart film has even more layers, on top of a paper base. As in many other analogue colour materials the image layer is made of three different layers, each containing developers for one of the colours magenta, cyan and yellow. Together, they form the full colour range of a photographic image. In the Polaroid process, on top of each of those three layers there is an additional layer with silver halides, like in black-and-white photography, but then sensitized only to the corresponding colour which would be developed in the underlying dye developer layer. So basically, every layer with one of the three dye developers is covered by a silver halide layer that is sensitized to the opposite colour. After exposure the dyes react with the exposed silver halides and the spread-out developing reagent. In exposed areas the dyes will be blocked. Only in light, unexposed areas, the dyes can move through all the layers towards the positive receiving paper where they will be mordanted. They diffuse and form the positive image. The exposed parts will be immobilized and stay in the negative part of the package. After peeling the two components apart one has a developed negative in one hand and a printed positive in the other. After that, a series of chemical reactions will first stop further diffusion than dry and harden the surface of the positive print.

With the peel-apart films, the negative has exactly the same size as the resulting positive. This means that there is no magnifying step in between negative and positive. Especially with the bigger formats this results in extremely high resolution and details. Even when examined with a magnifier one will only find more image details instead of parts of the film structure. There is no grain visible.

Integral Film
The technology of the second type of Polaroid films, the integral films, is even more fascinating since all the described steps of the peel-apart film are taking place in one package. The integral film came on the market together with one of the most ingenious cameras ever designed,

Edwin H. Land with a self-portrait made by his SX-70 camera
Photo by Joyce Dopkeen

the SX-70. The SX-70 film pack consists of 13 layers, two of them being the top and the bottom polyester layer that are sealing the whole package. The development chemicals are stored in the small white pocket on the bottom of the image. This small white frame with the bigger portion at the bottom became the iconic look of a Polaroid picture. Unlike the peel-apart film, the integral film had to be able to develop in the light because it was not covered by a sheet of negative. Immediately after exposure the camera moves the package out of the camera through the roller system, which will also rupture the pod and force the developing reagent in between negative and positive section of the package. Ingeniously, the engineers at Polaroid did add the so-called opacifier to the pod. When the chemicals spread within the package the opacifier also spreads and covers everything with a grey colour. That blocks out the light. Meanwhile, underneath, the dyes react with the exposed silver halides and the pod chemicals. The developed dyes in unexposed areas migrate to the surface of the package and the dyes in the exposed parts are immobilized and stay undeveloped in the underlying layers. As soon as this step is finished the opacifier turns into a clear and colourless compound and the positive image can appear. The technical perfection of the process is a big part of the whole Polaroid magic.

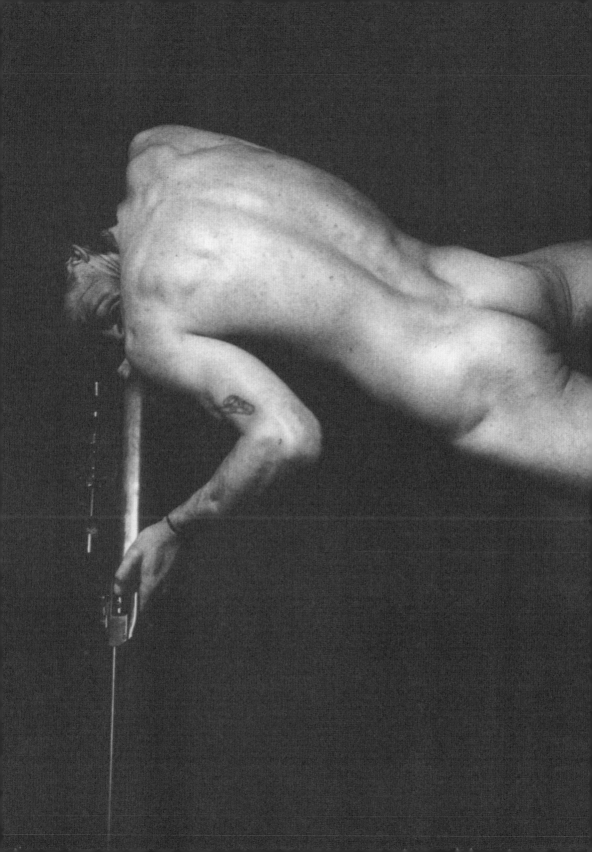

Polaroid Then and Now

It has been said that Polaroids are the daguerreotypes of the twentieth century. A parallelism which is true in many ways. Polaroids are always unique positive photographs. While making the image only one photographic object is produced. Even in the processes, where a negative is made together with the print, the print itself is irreproducible. To make this positive there is no intermediate step in a darkroom, no chance to make any corrections or manipulate the image other than while taking it.

The photographs made by Polaroid processes always have been quite unstable and prone to chemical degradation. Also, the medium has not been used massively. Both reasons for the rareness of the original material nowadays.

Photographer William Wegman, who worked a lot with 20 × 24 inch Polacolor film, says: 'I also like that each couple of years the balance of the film changes or they'll come up with a different paper.'[3] Polaroid photographs have a very specific look and colour saturation, incomparable to other techniques.

Polaroids as well as daguerreotypes were replaced by newer techniques, but the aura of being very delicate, special and unique photographic objects did stick to them. And that aura became even more vivid once those processes became obsolete and therefore became very precious to the few who still were able to practice them.

When Polaroid announced its bankruptcy it was clear to many that the material would die out sooner or later. There have been attempts to maintain Polaroid photography, but in a couple of years the material will certainly be history.

In 2008, John Reuter, director of the 20 × 24 studio in New York, founded 20 × 24 Holdings LLC and bought all the remaining Polacolor film material for the 20 × 24 format and put it in cold storage. His company keeps up the production of the necessary development pod. But the chemicals used for it have constantly been changed and replaced by others. Already back in the days of the Polaroid company the stability of the pod was quite short-lived. A stock of pod lasts for a maximum of six months. The stock of film material itself has been reduced and used by Reuter and artists who rented his studio over the years. There is still some left. But more recent tests showed growing problems in keeping up the quality of the resulting prints. The film material may be aged to such an extent that it will very soon be useless.

Another attempt to keep Polaroid photography alive was made by The Impossible Project. Former Polaroid staff members bought a Polaroid plant in Enschede, the Netherlands, and tried to continue producing Polacolor film and integral film. Very soon they became aware of the fact that a lot of the former used chemicals weren't available anymore. They tried to replace them with others, but the quality of the original material has so far never been reached.

3
Phyllis Linnehan, 'The Artistry of 20 × 24 Photography', *Photography Quarterly* vol. 20, no. 81 (2001), p. 4.

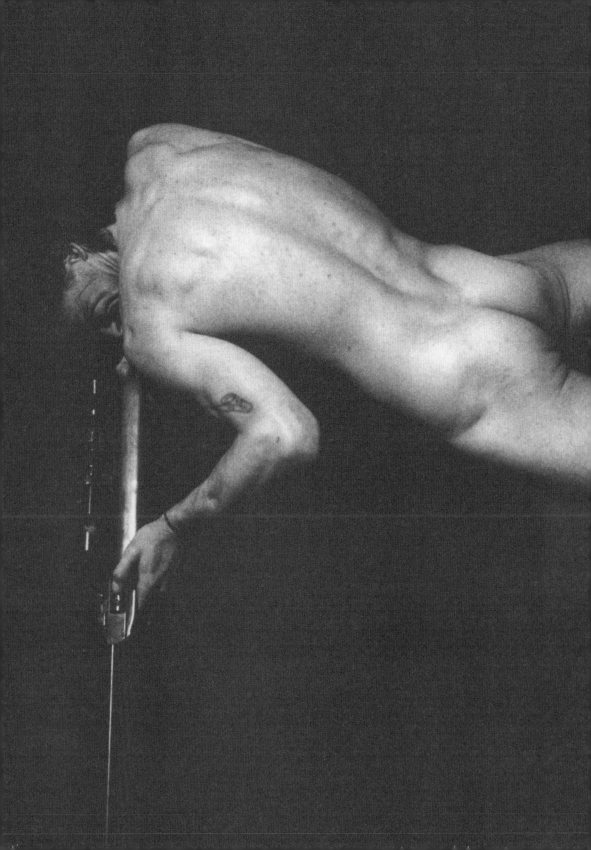

Large Format Polaroids -
The 20 × 24 and 40 × 80 Camera

After some years, the development
of the Polacolor film reached a point
where the main drawbacks of the first
years had been overcome and the image
quality had been improved signifi-
cantly. Edwin H. Land wanted to show
what excellent resolution of detail
and rendering of colours his peel-
apart film was capable of. In 1976
that led to some research at the labs
of the Polaroid company, guided by
John McCann, head of Vision Research
at Polaroid, to develop a way to
use the Polacolor film at much larger
formats. That same year the first
20 × 24 camera was built, producing
peel-apart Polaroids of 20 by 24 inch
(ca. 50 × 60 cm). Not much later,
even larger size Polaroids were pos-
sible, 40 × 80 inch (ca. 100 × 200 cm).
Basically, Polaroid ended up at
the very beginnings of photographic
systems. In the museum camera,
as the 40 × 80 camera was also called,
the camera obscura was reborn,
now equipped with a complex polaroid
system inside and some technicians
to get everything in motion.

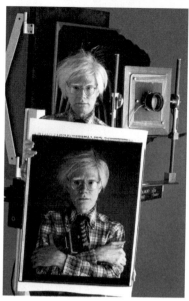

Andy Warhol with Polaroid print,
New York, 1980
Photo by Bill Ray
Warhol posed before the 20 × 24 Polaroid
camera, with the much smaller
SX-70 camera tucked under his arm.

The Polaroid 20 × 24 Camera
The very first 20 × 24 camera, invented
by Polaroid, weighed about 400 kg
and did not provide many possibil-
ities to adjust the parameters. Edwin
Land presented it at a shareholders'
meeting to demonstrate the quality
of the Polacolor film. The very first
shot was taken of a $ 2 bill, showing
every fibre in the paper. At another
occasion, a live portrait of Andy
Warhol was taken with the 20 × 24 cam-
era. It already demonstrated the
expected potential of the technique
as a mainly artistic medium.

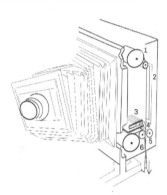

Technical drawing of the
Polaroid 20 × 24 camera
1 Roll of light sensitive negative paper
2 Focal plane fresnel viewer
3 Pods of reagent
4 Reagent deposited from pod
5 Motor-driven spreader rolls
6 Roll of dye receiving positive paper

After the presentation, the
20 × 24 camera underwent several
improvements and further development,
still weighing about 100 kg. In
total, five of these cameras were
built. A studio was installed at the
Boston Museum of Fine Arts to make
1:1 reproductions of art works.
It was also used by invited artists
and commercial photographers to
create large size Polaroid prints.
One camera was installed in Cambridge
(MA), at the studio of photographer

Elsa Dorfman, who is still working
with it. In 1986, another studio
opened in New York, run by John
Reuter. He made the camera available
to artists. The studio provided
the technical support for the complex
camera. For $ 800 one could rent
the studio together with the tech-
nician for a day. Each exposure cost
an additional $ 25.

In 1994, another 20 × 24 studio
opened in Prague and in 1997 in San
Francisco. The Prague camera travelled

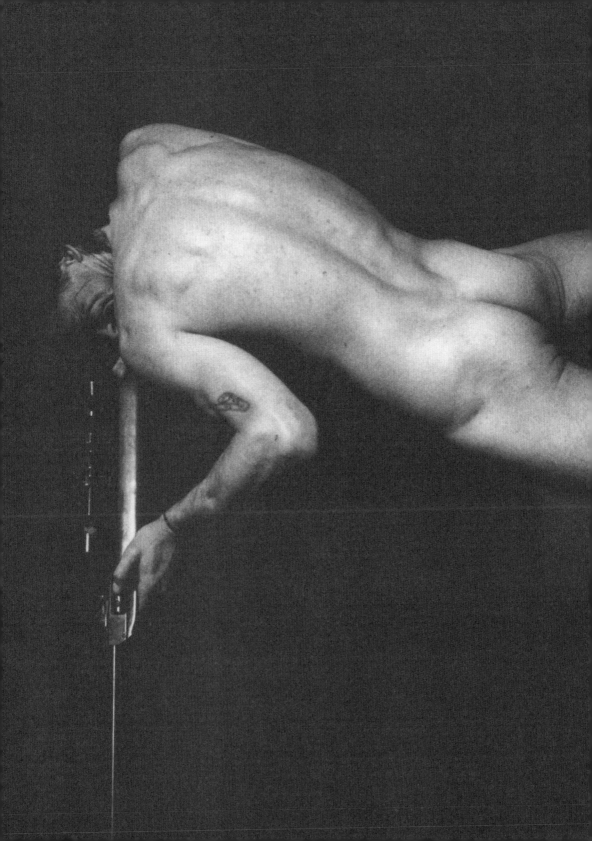

through Europe and appeared at different locations, one of them being Amsterdam.

The 20 × 24 camera works with the same principles as the smaller hand-held Polaroid cameras that produce peel-apart prints. At the back of the camera, a roll of negative film is mounted at the top. At the bottom is another roll, from which the positive receiving paper is hung. A long cap-sule of aluminium foil containing the pod is installed. The camera is closed and exposure takes place. The motor-ized rollers bring the negative and receiving paper together, rupture the pod and spread the chemicals within the sandwich while the package slowly finds its way to the outside. The package then rests and develops for 90 seconds and after that the negative can be peeled off.

Some of the 20 × 24 cameras are still in use today. Elsa Dorfman is still working and the New York studio of John Reuter offers its services to artists who are still working with the Polaroid material. Ulay is one of them. They are using the remaining Polaroid film material but, as noted earlier, soon that will come to an end.

The Polaroid 40 × 80 Camera
In 1976, shortly after the successful launch of the 20 × 24 camera, Edwin Land realized that being able to make such big Polaroid prints without having the disadvantages and loss of detail of enlargement, could open up a whole new field for his material. Again he turned to John McCann and told him he wanted to be able to make a perfect 1:1 reproduction of Renoir's *Le Bal à Bougival*. Not much later, Polaroid installed a gigantic camera at the Boston Museum of Fine Arts, where the painting hangs. The camera was able to make 40 × 80 inch peel-apart prints. The painting measures 71.6 by 38.6 inches (1.82 × 9.80 metres).

Essentially the 'museum camera' occupied an entire room of 3.5 × 3.5 × 5 metres. It had no real system of lenses, which allowed a true 1:1

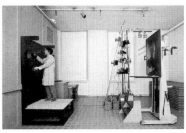

Technical drawing of the Polaroid 40 × 80 camera
1 Entrance
2 Roll of light sensitive negative paper
3 Pods of reagent
4 Roll of dye receiving positive paper
5 Strobe lights
6 Original

Technician working with the Polaroid 40 × 80 camera at the Boston Museum of Fine Arts

correlation between object and image. To bring things into focus they had to be placed in front of the camera in the right position. The camera was a walk-in system. Two technicians, a photographer and a camera operator, walked into the camera, closed the door and turned off the lights. Both wore infrared goggles to be able to see inside the camera without exposing the film to visible light. A roll of light-sensitive film material was mounted in the camera. In the dark, a piece of film was rolled off and sucked onto the vacuum film plane underneath the roll. By opening the lens shutter from inside, eight strong flashlights were triggered to illuminate the object in front of the camera, exposing the negative. The negative was then brought into contact with the re-ceiving paper and placed into the motorized roller system by the tech-nicians. The pod was ruptured and spread in between. The photographs were so big that it took two tech-nicians to peel away the negative and reveal the positive print.

4
Wild Men, Animals and Moors, ca. 1400, Germany, Upper Rhine.

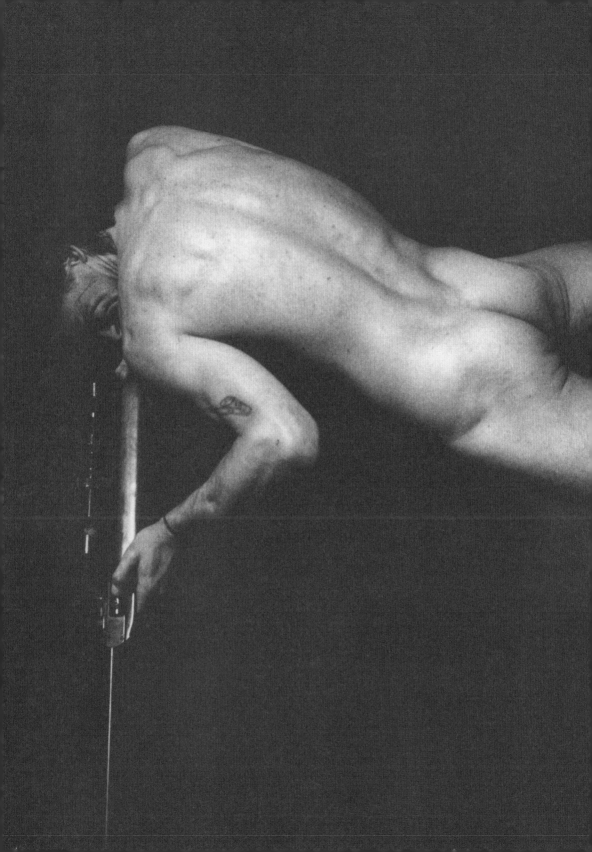

Scale model of the use of the Camera Camera,
reproducing Raphael's *Transfiguration*

Naturally, Polaroid was eager
to promote this revolutionary camera
system and show its incredible possi-
bilities. So, in 1977, the back of a
tapestry[4] from the fifteenth century
was reproduced 1:1. The colours of the
tapestry had faded due to light expo-
sure, but on the back much of the dyes
had been preserved. The reproduction,
made of multiple parts, measured
2 by 3 metres and was exhibited at the
Museum of Fine Arts in Boston.[5]

From that time on, the 40 × 80 cam-
era has been used to make high-quality
reproductions of famous paintings
at the Museum of Fine Arts in Boston.
First it was thought that it might
be a possibility to show the repro-
ductions instead of the originals,
that it could be a way to protect the
paintings from degradation by light.
Funnily enough, Polaroid prints
themselves proved much more sensitive
to light than the paintings ever
were. The originals will easily last
for a couple of hundred years more,
whereas the photographs never could
be on display for a whole year without
fading dramatically.

In 1979, a temporary setup of
the museum camera was installed at
the Pinacoteca Vaticana, called
the Camera Camera, because it was a
room-size camera. The same principle
as in Boston was applied by building
a room of scaffoldings made light-
proof with black, opaque polyester
foil. The aim was to make a high-
quality reproduction of *The Trans-
figuration*,[6] the last painting by
Raphael, shortly after it had under-
gone intensive restoration. The
3 × 4 metre painting had to be repro-
duced on location, so the camera
set-up was installed in front of it.
The framework construction of
7 × 6 × 6 metres allowed the lens to be
in different places while the paint-
ing was reproduced in parts. The whole
process resulted in four 1 × 3 meter
Polaroid photographs.

Additionally, the 20 × 24 camera
was used to photograph 13 special
details with a larger magnification.
Those details allowed a thorough
examination that could never have
been done with the original. The re-
sults have been proudly presented
in an exhibition, with an accompany-
ing publication: *A Masterpiece
Close-up: The Transfiguration of
Raphael*. It showed the whole process
as well as the reproductions that
were made. The exhibition also
included a model of the camera on a
'Barbie' scale.

5
A Medieval Tapestry in Sharp Focus,
exh. cat. Museum of Fine Arts
(Boston, 1977).

6
Both exhibition (1982) and publication
(1979) were titled: *A Masterpiece
Close-up: The Transfiguration of
Raphael*, see smartmuseum.uchicago.edu/
exhibitions/a-masterpiece-close-up-the-
transfiguration-of-raphael/

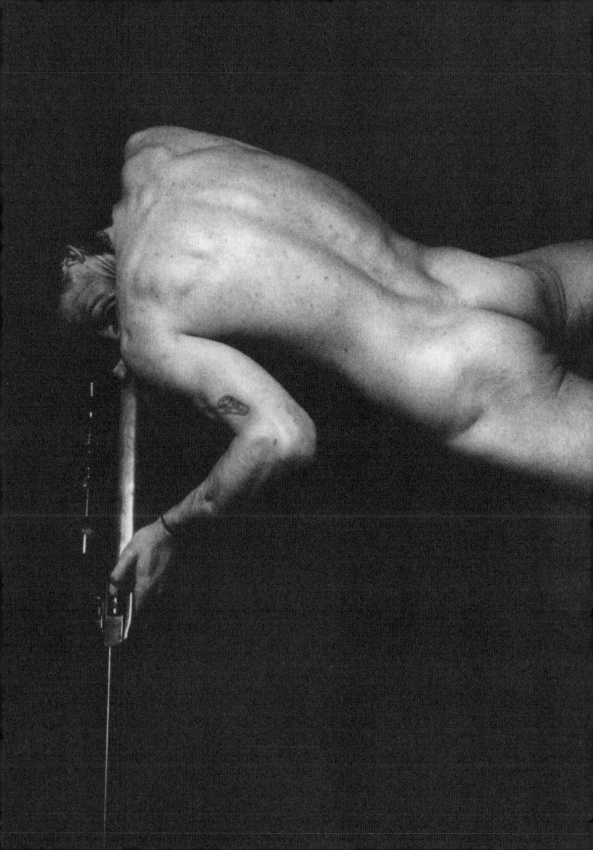

The Polaroid
Museum Replica Collection

Installation of Joe McNally's
portraits of 9/11 rescue workers
Faces of Ground Zero, 2002

Apart from the more spectacular proj-
ects done with the 40 × 80 camera
in the first years, for other purposes
it was necessary to find funding
for the cost-intensive technique. The
'Polaroid Museum Replica Collection'
was born: a collection of reproduc-
tions of the most famous paintings at
the Museum of Fine Arts in Boston,
which could be ordered by the public.
The catalogue of 1984 states that
'Each Replica is photographed actual
size from the original masterpiece at
the Museum of Fine Arts. Every brush-
stroke, crack, and textual nuance
is precisely captured in the Replica.
The detail is striking. The color
is faithful and durable. The likeness,
remarkable. The final touch for fine
interiors.' The price list offers more
than 30 different reproductions, for
prices up to $ 1.300,- for a single
unframed polaroid, depending on size.

Apparently the Replica Collection
wasn't such a success after all. There
were some buyers, mainly in Japan, but
not enough to keep this business go-
ing. Also, the relatively high insta-
bility of the prints didn't make them
such a suitable option for replacing
the original painting on display.

John Woolf (Digital Systems Manag-
er, Museum of Fine Arts): 'What most
people are unaware of, is that during
the last 5 to 10 years of Polaroid's
time at the MFA they modified their
process and did not make direct cap-
tures of the artwork for their repli-
cas. Because the material they used
was just large sheets of snap shot
instant film, the colour gamut and
dynamic range of the material was very
small and ill-suited for fine art
reproduction. While still capturing
directly on the large sheets of Polar-
oid film, the Polaroid technicians
used many extreme techniques to com-
pensate for the inabilities of their
film to reproduce colour accurately.
For instance, they would light a
painting with as many as 20 light fix-
tures, each with different coloured
filters to compensate for colour
shifts of certain colours in the orig-
inal art work. This approach was not
only time consuming, but ultimately
did not produce very good results. So,
in the late 1980s Polaroid engineers
used an early version of colour man-
agement software and a very high reso-
lution digital screen printer to make
colour corrected copy transparencies
which were then re-photographed onto
the large Polaroid film (both 20 × 24
and room sized). This approach in
effect turned the Polaroid cameras
into giant enlargers.'[7] The Cambridge
Historical Society reproduced its
rarer paintings, and to this day ex-
hibits the copies, keeping the origi-
nals in storage for safety reasons.

When Polaroid's decline set in,
the camera in Boston was dismantled.
It was put up for sale. Photographer
Gregory Colbert bought it. Together
with his partners Mark Sobczak and
Laurel Parker he started the studio
Moby C in New York.[8] The last big
project for which the camera was used
was when Joe McNally made 227 por-
traits of 9/11 rescue workers who came
straight from the site to the studio.
Each shot cost $ 300. After that the
stock of the film material for the
40 × 80 ran out and was never produced
again. McNally: 'At f/45, you have
about an inch of depth of field. You
cannot focus the lens - you have to
focus your subject by moving them back
and forth in tiny increments. There
is no shutter, you have to work camera
obscura at the moment of exposure.'[9]

7
Email conversation, 23 February 2015.

8
Frank Van Riper, 'Moby C, Joe McNally
& A Tribute to Heroes', *The Washington
Post Online*, www.washingtonpost.com/
wp-srv/photo/essays/vanRiper/011120.htm

9
blog.joemcnally.com/2008/07/08/
welcome-adorama/

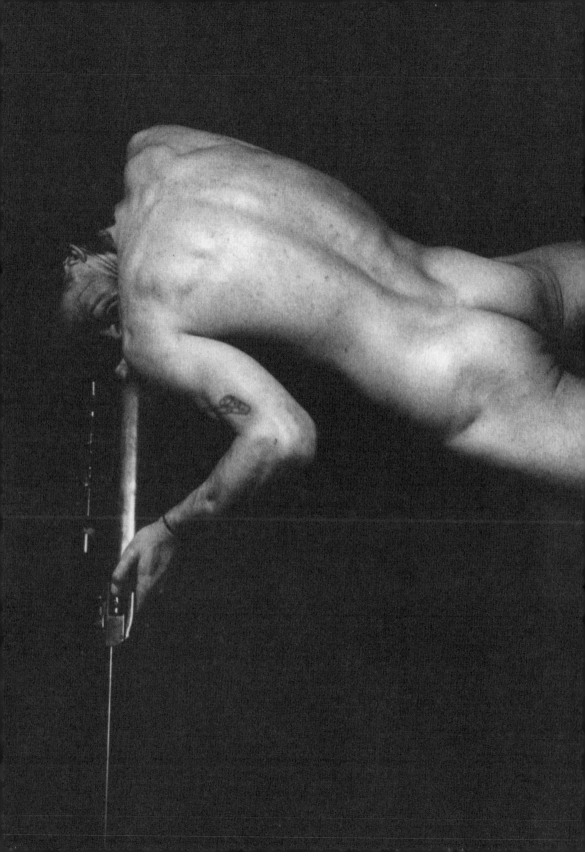

Ulay and Large Format Polaroids

Ulay used the 20 × 24 camera for the first time in Amsterdam in 1980. It marks the starting point of his second photography phase after he ended the first one by the legendary *FOTOTOT I* performance in 1976.

Beginning in the 1980s, the 40 × 80 camera was mainly used by artists who were invited by Polaroid. Among the artists who visited the studio were David Hockney, Evergon, Bill Wegman, Marie Cosindas and Chuck Close. Ulay was one of the more regular ones.

His first session with the 40 × 80 camera was in 1984, working on the *Modus Vivendi* series. Over the next few years he would return to the Boston studio regularly. Working with the large format Polaroids, he gives a performance; not in front of an audience but in front of the camera. The *performative photography* of his early days turns from a very intimate situation into a more public one.

Due to the complexity of the camera and the Polaroid peel-apart film the camera needed to be operated by a technician and in the case of the 40 × 80 camera even by two. It gives an un-immediacy to this direct and instant medium.

John Reuter (director of 20 × 24 studio): 'The director's role is to support the artist with technical and creative advice or to completely fade into the background, allowing the artist to engage with the process. The director still supervises all technical aspects, but can do so without intrusion.'[10]

In 1990, Ulay gains back some of the direct control over the material by stepping into the 40 × 80 camera himself and manipulating the light sensitive Polaroid material itself inside with a flashlight, different filters and his own body. His first Polagram is born.

Keitaro Yoshioka, later director of the 20 × 24 studio in Boston, was the photographer operating the museum camera on the day Ulay made his

Chuck Close, *Large Selfportrait*, 1980
Composite Polaroid 6 colour polaroids

nearly 3 metres long *Self-Portrait*. He remembers the circumstances that led to this extraordinary photograph and its extra-long measurements. 'Ulay had an experience working with Polaroid 20 × 24 camera prior to utilizing Polaroid 40 × 80 camera. He immediately figured out the difference between Polaroid 20 × 24 Camera and Polaroid 40 × 80 camera. The Polaroid 20 × 24 Camera is a truly large format camera which has all the large format camera movement such as tilt, shift, and swing where Polaroid 40 × 80 camera is just the room with a big lens. The camera does not move. You need to move closer or move away from the camera to focus. In fact, we used to have a forklift in the studio and we used it to focus the object. Ulay welcomed the difference of the camera. He also welcomed the unpredictable effects that we produced with this camera. His subject matter was rather simple and conceptual. He produced some beautiful work with the Polaroid 40 × 80 camera. Once again, I have such a great memories working with Ulay. He made us feel comfortable and fun while we were working with him.'[11]

When the exposure of *Self-Portrait* had taken place, negative and receiving paper together with the pod in between were placed into the roller system by the camera technicians.

10
Linnehan 2001 (see note 3), p. 6.

11
Personal conversation, 10 February 2015.

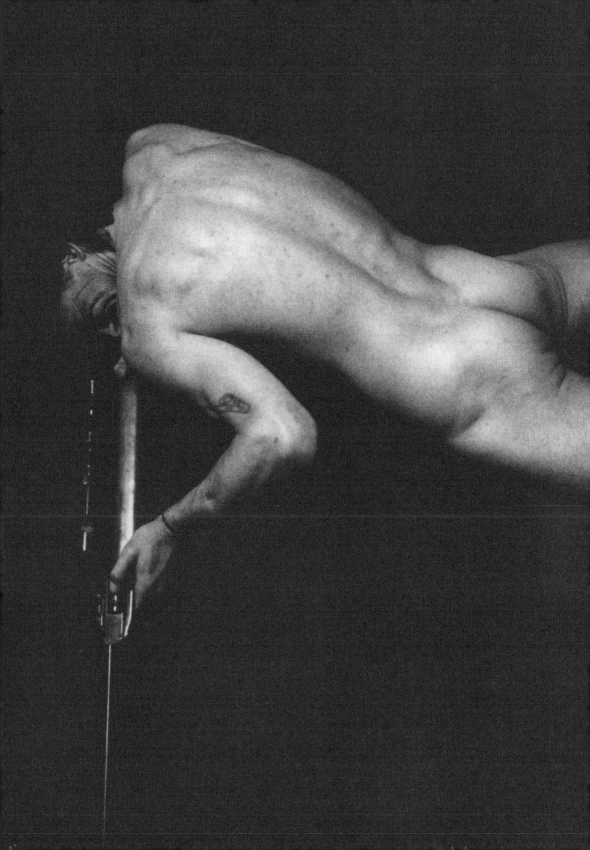

Now the motor started as usual, moving the two layers slowly through it and spreading the chemicals evenly. But at the moment the motor was supposed to stop automatically after having moved the whole exposed area through the rollers, it didn't. It kept moving for more than another 50 centimetres before the technician could stop it manually. As a result, the print ended in an irregular line at the upper end, because there were not enough chemicals in the pod to develop this extra and unplanned area of the photograph.

Ulay very much appreciated this unplanned incident and called it a lucky one, recognizing the unpredictable as the source for creating a unique and irreproducible image. He calls this work his favourite polaroid.

Ulay, *Self-Portrait*, 1990
Polagram, Boston Studio, USA

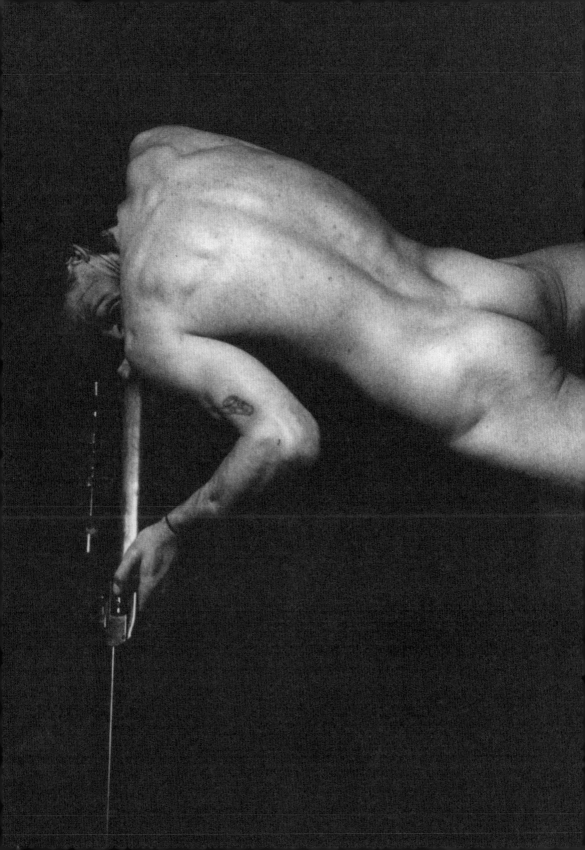

The Conservation of the Large Format Polaroids - 'Hätte ich den Sauerstoff nicht inhaliert, hätte er anderes oxydiert'[12]

Characteristics of Large Format Polaroid Prints

In order to treat a Polaroid print in the best possible way to maintain its long-term stability, it is necessary to identify the characteristics of this particular material.

Especially the large format Polaroid prints of the 20 × 24 and the 40 × 80 camera show some characteristic identification marks that one can look for in identifying the material.

· Tulip fields: the area on the upper short border with partially attached dyes in droplet form.
· Both long borders with squeezed-out dyes and discoloured pod chemicals. Those areas also show an impregnation of the roller system characteristic to each one of the cameras.
· Yellow discolouration at the bottom edge due to excessive pod chemicals which have been wiped away immediately after development, but have already discoloured the white baryta layer of the positive receiving paper.
· Slight relief in dark areas due to the larger volume of printed dyes on the positive receiving paper.
· Very small white spots with missing dyes due to small air bubbles on the image receiving layer, which disturbed the adhesion of the migrated dyes.
· Greenish colour shift in the blacks, especially when a studio flash has been used. Connoisseurs call this the typical Polaroid colour.

Image Stability

Ulay was concerned about the life expectancy of his Polaroids as soon as he heard rumours that the material might not be very stable. He assumed that it might be mainly due to 'not

Specially made transport and storage tubes for Ulay's large format Polaroids

enough love' for the photographs. So he invested in some specially made boxes and flight tubes for his works and moved everything very carefully from place to place. It shows his affection for the material aspects of his works. At the same time, when asked about ideas concerning the conservation of his photographs today, he says: 'Nothing is for eternity. I find it irrelevant.'

Still, in the process of selling a work he finds it necessary to give the new owner good advice on the right framing and treatment of the Polaroid. At Polaroid the stability of the film material has been studied. The very first types of the peel-apart films had to be coated by a varnish to keep the images from fading. Even when that problem had been overcome it appeared that the dyes used in the Polacolor film material were quite unstable. Soon after development, the colours would fade and the prints would stain, especially when exposed to light for some time. In 1975, Polaroid improved the dyes used in the peel-apart film now called Polacolor 2 by metallizing them. Those dyes were developed for the SX-70 integral film and made the colours significantly more stable against fading.

12
'If I wouldn't have inhaled the oxygen, it would have oxidized something else.'

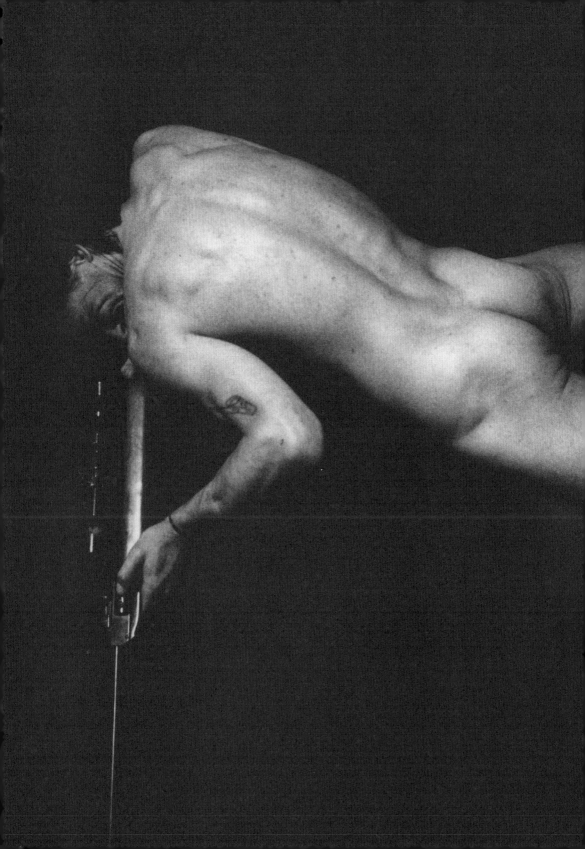

The light stability of the prints was mainly of concern for the *Museum Replica Collection*. For about $ 14,000 one could get a replica mounted on *gatofoam* and protected by an UV light absorbing matte finish. John McCann himself developed the protection spray and did some tests to improve the framing of the replicas to enhance their long-term stability. However, when exposed to light for some time the prints faded anyway.

Main Factors for Degradation
There are various materials involved in the Polaroid film, especially the colour material. Paper, different polymeric binders (cellulose acetate, polyester, polyvinylalcohol), azo dyes (from 1975 on in metallized form), silver halides. With the pod, a lot of other ingredients are added to the package that contain possible sources for further chemical interaction with the image forming substances. With the peel-apart films most of the chemicals are discarded with the negative, but in the integral film everything stays inside. As a consequence, the latter shows the most inferior image stability compared to other Polaroid material.

Considering the chemical complexity of Polaroids it is remarkable that there are many examples of originals in very good shape. It has been assumed that the residues of chemicals left on the surface of the emulsion must provoke some chemical reactions. Those should alter the image or at least accelerate the aging behaviour of the dyes.

In view of that, it is interesting to see that dye fading will most often appear very evenly spread over the whole area of a Polaroid and no traces of former spread solutions are visible. There are also many examples of developed Polacolor film never exposed to light, stored tightly rolled up for several decades now. You would imagine, that the rolled up storage should accelerate any chemical reaction even more, because of accumulating gases on the emulsion surface, but those prints are often in excellent shape, with no noticeable colour change.

If you look at the chemical reactions taking place as soon as the pod

Detail of an Ulay 40 × 80 Polaroid: Tulip fields at the upper edge of the print

Detail of an Ulay 40 × 80 Polaroid: Scratches in the image layer, manipulation of the print by the artist

Detail of an Ulay 40 × 80 Polaroid: Excessive developer and image dyes along the side edge of the print

is being spread over the emulsion, you will see how well everything is timed. There are different agents present that will slow down or even stop one reaction to let the next one get started. At the end, every development stops and the emulsion is hardening so that it is not porous and open anymore. Everything stabilizes so that no further treatment is necessary. This is all well thought through by the Polaroid engineers and it is quite possible that the stabilization is good enough to even work while the prints are aging.

After all, it is obvious that the influence of light is the key factor in the conservation of Polaroid prints. Light, especially UV light, brings a lot of energy into the material. That energy can cause a number

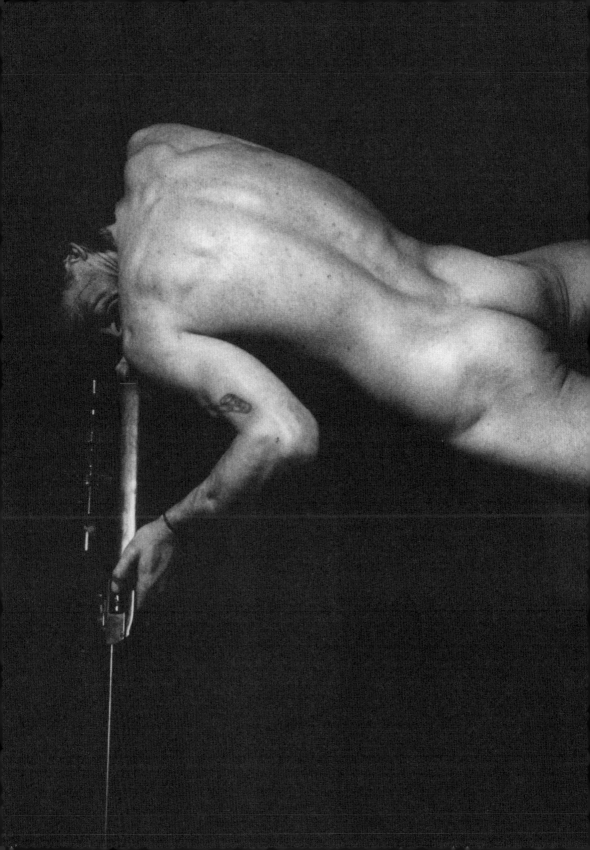

of degradation processes to take place, mainly oxidation processes, which can transform the dyes into colourless versions. That will result in the fading of the involved dyes and cause a colour shift in the print. Factors as climate and volatile pollutants from the surroundings of the Polaroid can accelerate the fading.

The older the polaroid colour print, the poorer the light stability. And in general the light stability is quite poor compared to other colour photographs. As mentioned, the integral film is even less light stable. The dark stability of the latter is also quite poor due to the residual chemicals in the film package, which can cause migration of unprocessed dyes to the top and subsequent discolouration. The dark stability of the Polacolor films is superior to other colour processes. Besides fading of the dyes there are other possible threats to the stability of the Polaroid prints. Larger formats may have protective spray or layers on top of the emulsion, which may yellow or otherwise degrade with time. The very early SX-70 prints (before 1976) can show some cracking in the image receiving layer. Handling of large format prints can cause serious creasing, dents and other mechanical damage. Therefore most of the time prints will be mounted on some rigid support, which may cause other interactive problems depending on the chosen support material and adhesive used for mounting. The mounting itself may cause disturbing finger- and handprints on the emulsion when carried out without gloves. Those fingerprints may cause some staining and fading of the image areas in the future.

Recommendations for the Conservation of Polaroid Prints
To avoid serious mechanical damage it may be better to avoid extensive handling of the large format prints, since every handling will increase the risk of making dents, creases or tears. For protection, suitable

Detail of an Ulay 40×80 Polaroid: Fingerprints on the image layer

Ulay 40×80 Polaroid: Planar distortion due to deformation of the mounting plate, the print comes off the plate partially

mounting and framing are the most effective means.

When mounted it has to be considered that the peel-apart prints are very sensitive to moisture and water. It is advised to use a non-aqueous system for the mounting. The material used for mounting and framing may not be able to evaporate any harmful gasses, which can cause image alteration. For this one can stick to the general recommendations given for photography.[13] All material used in direct contact with the Polaroids should have a pH of 7 to 8.5.

During storage, avoid direct contact with other photographic processes to prevent chemical interactions. Exclude air pollutants from the direct storage environment.

Controlled, stable lower temperature and balanced humidity levels will furthermore increase the image stability. Recommendations for long-term storage of Polaroid material are a storage environment at 4 to 10°C. But only if stable and controlled. Otherwise a stable temperature at 15 to 20°C is recommended, although with the latter the dye stability will last shorter than when stored at lower temperatures. In both cases humidity levels should be stabilized in between 30 and 50% to avoid any

13
See Photographic Activity Test; the PAT is an international standard test (ISO18916) for evaluating photo-storage and display products.

cracking in between the layers of the Polaroid material. Especially the SX-70 prints should never be stored at sub-zero temperatures, because of the serious risk for disturbance in between all the layers within the Polyester package.

Once again, and by the way this is also true for many other colour photographic processes, light and especially UV light is the most harmful factor for the long-term stability of the Polaroid images. Light will rapidly cause fading of the dyes. This is an irreversible process and has to be avoided through efficient measures. The exposure to light should be limited to a maximum of 12,000 lux hours per year and 50 lux during exhibition. Always use 100% UV filtered light. A framing system with a 100% UV filter in the glazing may be even safer.

If you are in possession of an Ulay Polaroid it is possible that the surface has once been treated by the artist himself with a special mixture involving original Swiss weapon oil. He did use that from time to time to clean the surface of disturbed prints. Although interesting in itself, it is not considered a recommended conservation method.

Selected Literature

Adams, Ansel. *Polaroid Land Photography.* Boston, 1979.

American Perspectives: Photographs from the Polaroid Collection. Exh. cat. Tokyo Metropolitan Museum of Photography. Tokyo, 2000.

Bonanos, Christopher. *Instant: The Story of Polaroid.* New York, 2012.

Bonanos, Christopher. 'Instant Artifact: The Museum Camera', 30 September 2013, www.polaroidland.net/2013/09/30/instant-artifact-the-big-camera-911-and-joe-mcnally/

Coeln, Peter et al. *From Polaroid to Impossible: Masterpieces of Instant Photography.* Ostfildern, 2012.

Crist, Steve, and Barbara Hitchcock. *The Polaroid Book: Selection from the Polaroid Collections of Photography.* Cologne, 2008.

Hitchcock, Barbara. *Innovation Imagination: 50 Years of Polaroid Photography.* New York, 1999.

Instant fotografie. Exh. cat. Stedelijk Museum, Amsterdam, 1981.

Kröncke, Meike, Barbara Lauterbach, and Rolf F. Nohr. *Polaroid als Geste: Über die Gebrauchsweisen einer fotografischen Praxis.* Ostfildern, 2005.

Lischka, Gerhard Johann. *Das Sofortbild: Polaroid.* Bern, 1977.

Lombino, Mary-Kay. *The Polaroid Years: Instant Photography and Experimentation.* Munich, 2013.

Mesquit, Teresa, and Barbara Lemmen. 'Coatings on Polaroid Prints'. In *Coating on Photographs: Materials, Techniques, and Conservation.* Ed. by Constance McCabe, pp. 22-47. Washington D.C., 2005.

Panzer, Mary. 'Big Artists, Big Camera: Not a Typical Polaroid', *The Wall Street Journal*, 6 August 2008, www.wsj.com/articles/SB121797626872014909

Pénichon, Sylvie. *Twentieth-Century Color Photographs.* Los Angeles, 2013.

The film *Camera Ready: The Polaroid 20 × 24 Project* by John Reuter will most probably be released in 2016. www.20x24studio.com/?p=2291

*Credits of
Ulay's Works*

© All works, Ulay

Uneven pages
of this book
Soliloquy, 1972
From the series
Renais sense

p.1-7
Ulay, *What Is This Thing
Called Polaroid?*, 2015
Series of 10 drawings,
felt-tip pen on paper
Each 21 × 14.9
and 14.9 × 21 cm

p.15
Ulay, *Soliloquy* 1974
From the series
Renais sense
Auto-Polaroid type 107
Each 8.5 × 10.8 cm

p.19
Ulay, *Auto-Portrait* 1970
Auto-Polaroid type 108
10.8 × 8.5 cm

p.27
Ulay, *Keine Möglichkeit
2 Platzwunden (with
Jürgen Klauke)* 1975
Performance documentation
from De Appel,
Amsterdam, NL
Polaroid type 107
Each 8.5 × 10.8 cm

p.29
Ulay, *Renais sense
Aphorism* 1972-1975 (1973)
From the series
Renais sense
Auto-Polaroid type 108,
montage
Each 51.5 × 63.5 cm
(frame)

p.31
Ulay, *GEN.E.T.RATION
ULTIMA RATIO* 1972
Polaroid type 107
Each 10.8 × 8.5 cm

p.33
Ulay, *Untitled*, 1975
Collage, ca 14 × 11 cm

p.35
Ulay, *FOTOTOT I* 1976
Performance documentation
from De Appel,
Amsterdam, NL
Gelatin silver print
Each 27.3 × 34.8 cm

p.37
Ulay and Marina
Abramović, *Relation
in Space* 1976
Performance, 58 min.,
XXXVII. Biennale
di Venezia, Giudecca
© Ulay & Marina Abramović

p.39
Ulay, *Anagrammatic
Body Aphorisms* 1974
From the series
Renais sense
3 Auto-Polaroids type 107
Each 8.5 × 10.8 cm

p.43
Publication *Ulay /
what is that thing
called photography*,
Artists' Books Johan
Deumens (Landgraaf/
Heerlen), 2000

p.49
Ulay, *Soliloquy* 1972
Polaroid type 108,
handwriting
10.8 × 8.5 cm

p.51
Ulay, *Anagrammatic
Body* 1972
From the series
Renais sense
Mixed media,
Polaroid type 107
29.7 × 21 cm

p.53 (top)
Ulay, Jürgen Klauke and
friend together for the
book *Ich und Ich*, 1970
Polaroid type 58
Each 5 × 4 inch
(12.7 × 10.16 cm)

p.53 (bottom)
Ulay, *Ich und Ich*, 1970
Two images for the book
Ich und Ich (published
in 1972) in collaboration
with Jürgen Klauke
Polaroid type 57
Each 5 × 4 inch
(12.7 × 10.16 cm)

p.55
Ulay, *Untitled* 1972
TV documentation
of the Munich massacre
during the 1972 Summer
Olympic Games
Polaroid type 107
8.5 × 10.8 cm
Series

p.57-59
Ulay, *Renais sense*,
loose paper edition for
Galerie Seriaal, 1970
Sheet size 53.3 × 36.7 cm

p.61
Ulay, *Bloemendaal
Soliloquy* 1973
From the series
Renais sense
Auto-Polaroid type 107
10.8 × 8.5 cm

p.63 (top)
Ulay, *S'he* 1973-1974
From the series
Renais sense
Auto-Polaroid type SX-70
Each 7.9 × 7.9 cm
Rabo Art Collection

p.63 (middle)
Ulay, *S'he* 1973
From the series
Renais sense
Auto-Polaroid type 107
Each 8.5 × 10.8 cm

p.63 (bottom)
Ulay, *White Mask*
1973-1974
From the series
Renais sense
Auto-Polaroid type 108
Each 8.5 × 10.8 cm

p.65
Ulay, *Soliloquy* 1974
From the series
Renais sense
Auto-Polaroid type 107
Each 8.5 × 10.8 cm

p.67
Ulay, *China Ring* 1987
Polaroid/Polacolor,
New York Studio
Each 70 × 55 cm
Rabo Art Collection

p.47, 69, 107
Ulay, *Self-Portrait* 1990
Polagram (light expo-
sures with torch and
colour filters directly
on the negative),
Boston Studio
288 × 112 cm
Rabo Art Collection

p.71
Ulay, *New York Afro-
American Homeless* 1992
From the series *Can't
Beat the Feeling - Long
Playing Record*
Polaroid/Polacolor,
New York Studio
70 × 55 cm
Collection Stedelijk
Museum Amsterdam, NL

p.73
Ulay, *Untitled* 1993
6 Polagrams (light
exposures with torch and
colour filters directly
on the negative),
Boston Studio
Each 240 × 112 cm

p.75
Ulay, *Untitled*, 2000
Polaroid Colour
Integral 500 film
11.1 × 6.4 cm

p.77
Ulay, *Untitled* 2000
Polaroid chromogenic
print
19 × 15 cm
Original print 70 × 55 cm
Rabo Art Collection

p.79
Ulay, *JOY*, 2015
Fuji Instax Wide
Each 8,5 × 10.8 cm
The Rabobank's Art
Department invited Ulay
to make a series of
100 unique Polaroids
to celebrate his exhi-
bition in Fotomuseum
Rotterdam, 2016.
Together they form the
series *JOY*. They were
sold separately to
Rabobank employees at
the annual Art Offer.

*Reproduction
Photography,
Photos, Film Stills*

Baker Library,
Harvard MA p.101
Boston Museum of Fine
Arts, MA p.99 (b)
Joyce Dopkeen p.93
Eames Office p.83 (b)
Joe McNally p.103
Monroe Gallery of
Photography, Santa Fe, NM
p.97 (t)
Nederlands Fotomuseum,
Rotterdam, NL pp. 57,
59, 75
Bill Ray p.97 (t)
Pace Gallery,
New York, NY p.105
Katrin Pietsch pp.97 (b),
99 (t), 109, 111, 113
Polaroid Corporation
pp.85, 91
Ilya Rabinovich
p.73 (b-right)
Rabo Art Collection
pp.47, 63, 67, 69, 77,
79, 107
Stedelijk Museum
Amsterdam, NL p.71
Jan Stratman p.21
Jerry L. Thompson
p.83 (t)
Oliviero Toscani p.87
WestLicht Collection,
Vienna, AT p.87

(t) = top; (b) bottom

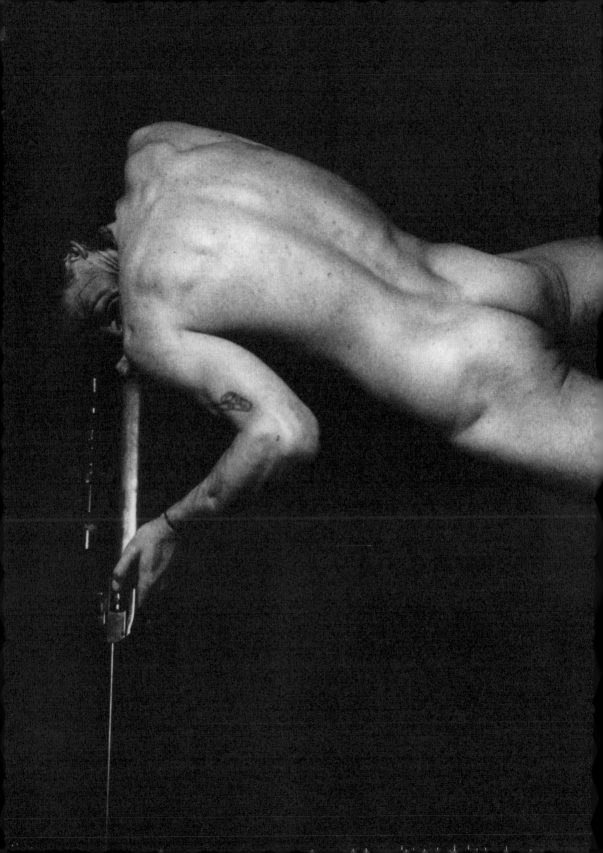

Ulay is the pseudonym of Frank Uwe Laysiepen. He was born in 1943 in Solingen, Germany. Ulay was formally trained as a photographer, and between 1968 and 1971 he worked extensively as a consultant for Polaroid. In the early stages of his artistic activity (1968-1976) he undertook a thematic search for understandings of the notions of identity and the body on both the personal and communal level, mainly through series of Polaroid photographs, aphorisms and intimate performances. At that time, Ulay's photographic approach was becoming increasingly performative and resulted in performative photography (*FOTOTOT*, 1976). In the later stage of his early work, performative tendencies within the medium of photography were transformed completely into the medium of performance and actions (*There Is a Criminal Touch to Art*, 1976). From 1976 to 1988, he collaborated with Marina Abramović on numerous performances; their work focused on questioning perceived masculine and feminine traits and pushing the physical limits of the body (*Relation Works*). After the break with Marina, Ulay focused on photography, addressing the position of the marginalized individual in contemporary society and re-examining the problem of nationalism and its symbols (*Berlin Afterimages*, 1994-1995). Nevertheless, although he was working primarily in photography, he remained interested in the question of the 'performative', which resulted in his constant 'provocation' of audiences through the realization of numerous performances, workshops and lecture-performances. In recent years, Ulay has been mostly engaged in projects and artistic initiatives that raise awareness, enhance understanding and appreciation of, and respect for, water (*Earth Water Catalogue*, 2012). Ulay's work, as well as his collaborations with Marina Abramović, is featured in many collections of major art institutions around the world, such as: Stedelijk Museum Amsterdam; Centre Pompidou Paris; Museum of Modern Art New York.

After four decades of living and working in Amsterdam, several long-term artistic projects in India, Australia and China, and a professorship of Performance and New Media Art at the Staatliche Hochschule für Gestaltung in Karlsruhe, Germany, Ulay currently lives and works alternately in Amsterdam, the Netherlands and Ljubljana, Slovenia.

Recent solo exhibitions and performances include:

A Skeleton in the Closet, Stedelijk Museum Amsterdam (NL, 2015)
Code of Conduct, 5th Thessaloniki Performance Biennale (GR, 2015)
'Early Works of Ulay', Açık Ekran Yeni Medya Sanatları Galerisi, Istanbul (TR, 2015)
Feature Section at Art Basel / MOT International (CH, 2015)
Project Cancer, Motovun Film Festival, Zagreb (HR, screening 2014)
'Da ist eine kriminelle Berührung in der Kunst', Venice International Performance Art Week, Venice (IT, screening 2014)
'Ulay', MOT International, London (UK, 2013)
'Ich bin Ich: Ulay on Ulay', Salon Dahlmann, Berlin (DE, 2013)
'Whose Water Is It?' Maribor (SI, 2012); European Capital of Culture, Slovenia (SI, 2012)
'The Great Wall Walk', C-Space, Beijing (CN, 2011)
'Ulay in Patagonia', Outline Foundation, Amsterdam (NL, 2010)
'ULAY - Preview of Historical Works', MB Art Agency, Amsterdam (NL, 2010)

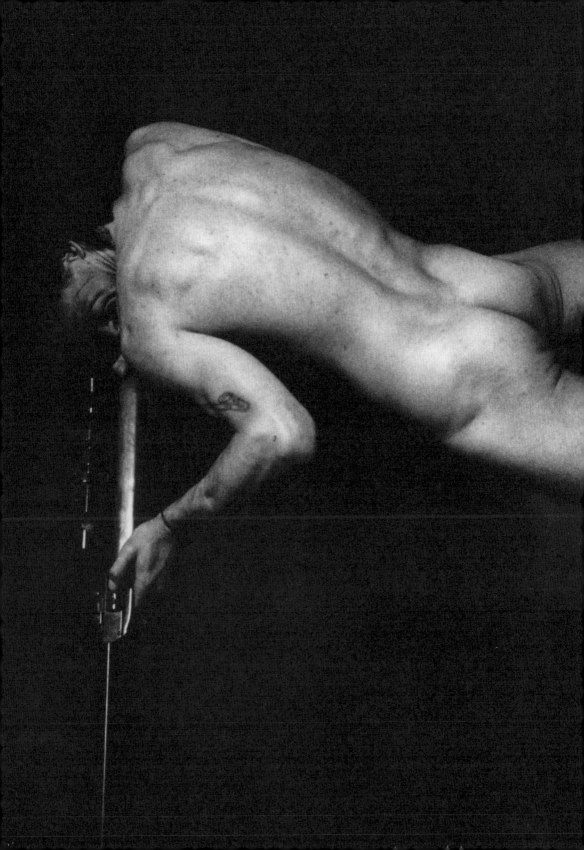

About the Authors

Frits Gierstberg is an art historian and publicist, who works as a curator at the Nederlands Fotomuseum, Rotterdam. He intermittently writes about historical and contemporary photography in international magazines and exhibition catalogues. He was closely involved in the making of the exhibition 'Ulay | Polaroids' at the Nederlands Fotomuseum (January - May 2016), featuring key works from the Rabo Art Collection and other art collections.

Katrin Pietsch works as a photograph conservator at the Nederlands Fotomuseum. She researches, preserves and conserves photographs in the museum's own collection and also works for other organizations. Since 2013, she has been a consultant for the Rabo Art Collection, advising them about the conservation of its photographic collection, especially the Polaroids. Within this context, the Rabo Art Collection commissioned an extensive study of Ulay's large Polaroids in 2015.

Documentary Film

Where Did the Image Go?
Ulay: A Life in Polaroid
A documentary film by Charlotte Ebers and Stijn van der Loo

In the documentary *Where Did the Image Go?* Ulay, in his Ljubljana studio, looks back intensely and honestly on his life and work. The camera follows the artist in a rediscovery of images from the past, documenting Ulay's visits to his own depot in the Netherlands and to that of the Rabo Art Collection. There he sees important works and his Polaroid cameras again for the first time in more than twenty years.

You can view or download the documentary film via this link:
www.rabobank.com/film-ulay

Acknowledgements

Special thanks go to:

Maria Rus Bojan
Lena Pislak
Ulay Foundation

Nafis Azad
Elsa Dorfman
Stephen Herchen
Ted McLelland
Teresa Mesquit
John Reuter
Stanley Rowin
Keitaro Yoshioka

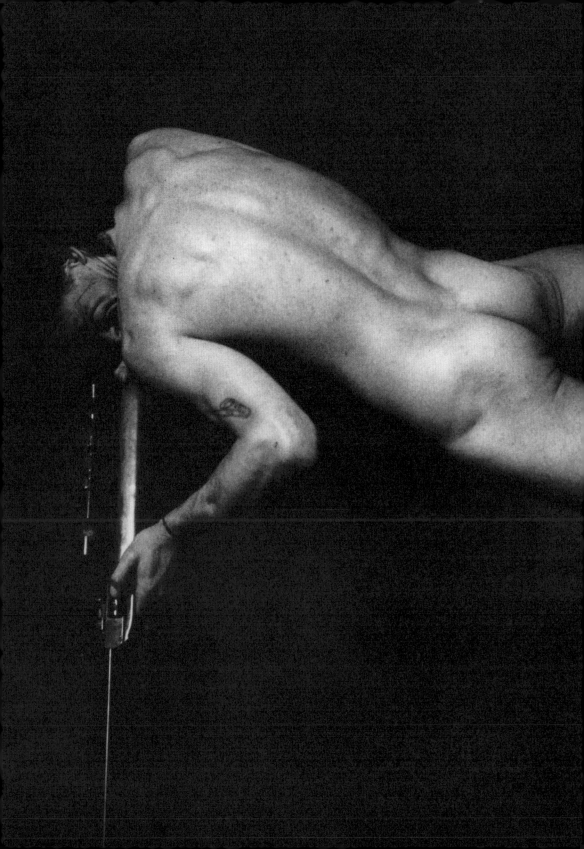

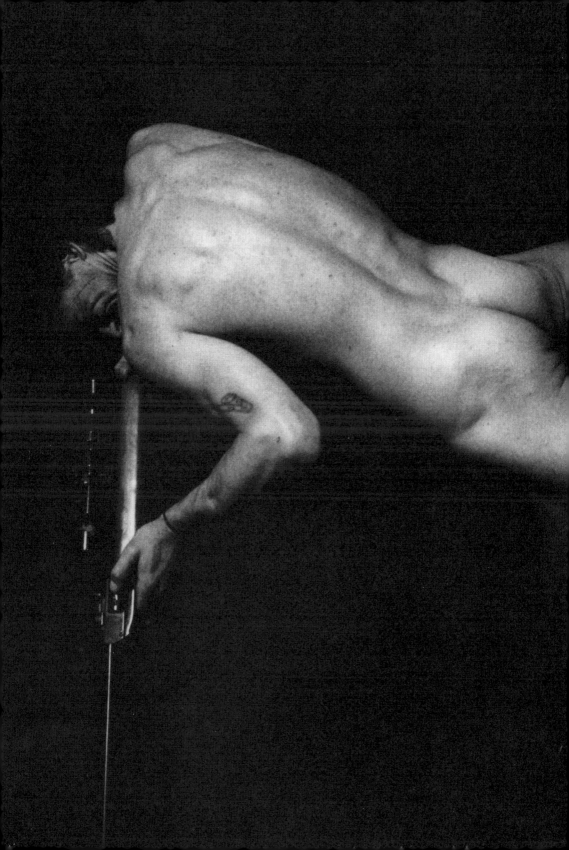

Colophon

Ulay, What Is This Thing Called Polaroid?

This publication has been released parallel to the exhibition 'Ulay | Polaroids', 23 January – 1 May 2016 at the Nederlands Fotomuseum, Rotterdam.

Authors
Frits Gierstberg,
Katrin Pietsch
(Nederlands Fotomuseum, Rotterdam)

Editors
Pia Pol, Leo Reijnen,
Astrid Vorstermans

Translation
Peter Mason (text Gierstberg)

Image editors
Ulay, Sonja Haller, Pascal Brun

Advice to the exhibition and publication
Maria Rus Bojan, MB Art Agency

Production Nederlands Fotomuseum
Marieke Wiegel, Celine van Kleef

Proofreading
Els Brinkman

Index
Elke Stevens

Graphic design
Haller Brun

Typefaces
Univers Next, Atlas Typewriter

Production publication
Valiz Foundation

Paper inside
Fluweel 1.5, 100 grams
HV satinated mc, 135 grams

Paper cover
Splendorlux, superwhite glossy,
250 grams

Lithography
Wilco Art Books, Amsterdam

Printing
Wilco, Amersfoort

Publisher
Valiz Foundation, Amsterdam in cooperation with the Nederlands Fotomuseum, Rotterdam

© Ulay, Amsterdam; authors; artists; Valiz Foundation, Amsterdam; Nederlands Fotomuseum, Rotterdam
2016

For works of visual artist affiliated with a CISAC-organization the copyrights have been settled with Pictoright in Amsterdam.
© 2016 c/o Pictoright, Amsterdam.

The publisher, artist and authors have made every effort to secure permission to reproduce the listed material, illustrations and photographs. We apologize for any inadvert errors or omissions. Parties who nevertheless believe they can claim specific legal rights are invited to contact the publisher: info@valiz.nl

Distribution
BE/NL/LU: Coen Sligting,
www.coensligtingbookimport.nl;
Centraal Boekhuis,
www.centraal.boekhuis.nl
GB/IE: Anagram Books,
www.anagrambooks.com
Europe/Asia: Idea Books,
www.ideabooks.nl
USA: D.A.P.,
www.artbook.com
Individual orders:
www.valiz.nl; info@valiz.nl

ISBN 978 94 92095 13 8
NUR 652, 642, 653

Printed and bound in the EU

Rabo Art Collection
Since 1995, Rabobank has been building a top-level collection of modern and contemporary art, characterized by critical keenness and depth of content. The focus lies on pioneers of their age. In close consultation with these artists key works are selected that mark a turning point in their oeuvre and together these works tell the story of not only the artists but of Dutch contemporary art as a whole. The Rabo Art Collection truly reflects Dutch contemporary art since 1950.
Since 2009, international artists have been added to this Dutch base. By now, three narratives define the collection: mankind, society, and 'the idea'. The collection thus offers a view of our world, contributing to the preservation of tomorrow's cultural heritage.
Art is all about stories. Stories about life and how we relate to life. And stories only come truly to life in the process of telling them. This is why the Rabo Art Collection is happy to share its treasures with a wide audience, as a source of knowledge, inspiration and encounters.

This publication was made possible through the generous support of Rabobank.

Rabobank

nederlands **fotomuseum**

valiz

www.nederlandsfotomuseum.nl
www.rabobank.com/art
www.valiz.nl